SEEING REALITY

Humanity, Humility and Humor

JERRY GAY

Pulitzer Prize Winning Photojournalist

Foreword by

ROBERT FULGHUM

New York Times Best Selling Author

Book Publishers Network
PO Box 2256
Bothell, WA 98041
425-483-3040
www.bookpublishersnetwork.com

10 9 8 7 6 5 4 3 2 1

Printed in the United States of America

LCCN: 2010910778

ISBN10: 1-935359-48-7

ISBN13: 978-1-935359-48-7

Advisors:
Keith Eyer
Mary Kay Krause
Barbara Kindness

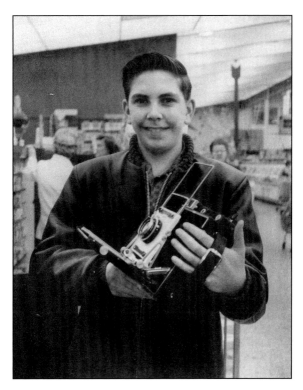

Jerry at age 12.

Dedicated to the young at heart who look to see the very best in everyone and reality in everything.

FOREWORD

"Look" was the first word I learned to read. It was the seminal word in the Dick and Jane series of readers for rookies in kindergarten. I still remember the text: "Look. See. Jane. See Jane run. Oh Look and see!"

When I became a teacher of drawing and painting I wrote those words on the wall of my art studio and drilled them into my students' psyche. An artist must learn to Look and See the world as it is with open eyes and mind – not at the world as we think we see it.

As a writer those words remain my mantra. Look. See. Carefully noticing the world and trying to make sense of what I see is my most important task – not just as a wordsmith, but as a human being.

As a photographer and deeply sensitive human being, my friend, Jerry Gay, has a powerful capacity to Look and See and capture on film unforgettable images that speak with eloquence to those willing to consider them carefully. This collection of his photographs moved me to smile and laugh, to tear up and shake my head, and to ponder again the amazing dimensions of the human experience. I trust it will be the same for you.

Look and See.

Robert Fulghum

Author of *All I Really Need to Know I Learned in Kindergarten*

www.theotherjerry.com

SEEING REALITY

In our mind's eye every meaningful thought contributes to our attitudes, common sense, spiritual insights and sense of reality. These characteristics create our personality which determines how we respond to moments of opportunity and responsibility in our everyday interactions. During our entire lifetime we are learning lessons to motivate feelings of humanity, humility and humor to improve our individual reality and collective destiny.

In reality, seeing is believing.

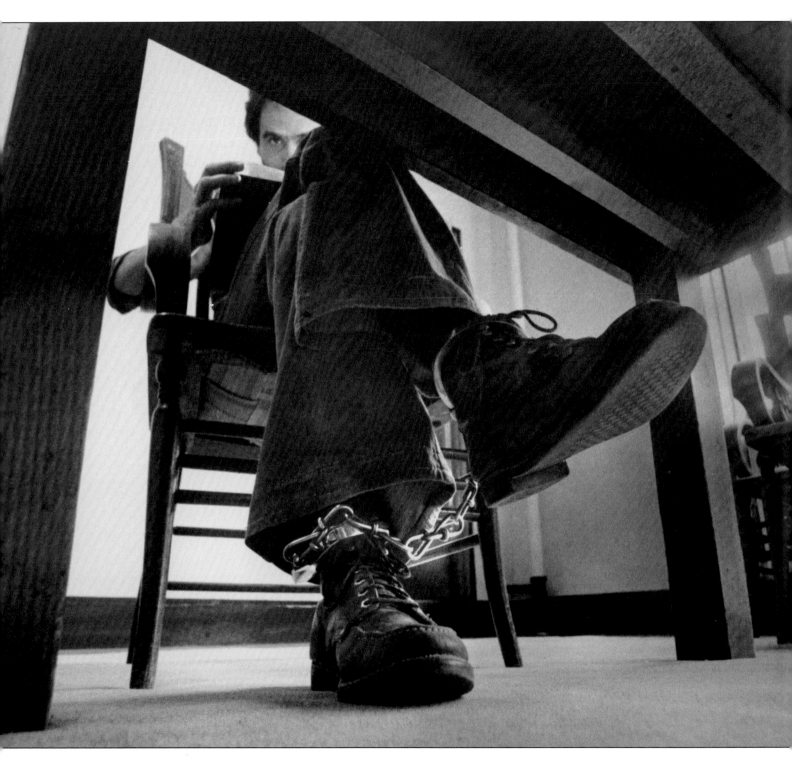

Ted Bundy in custody, 1976

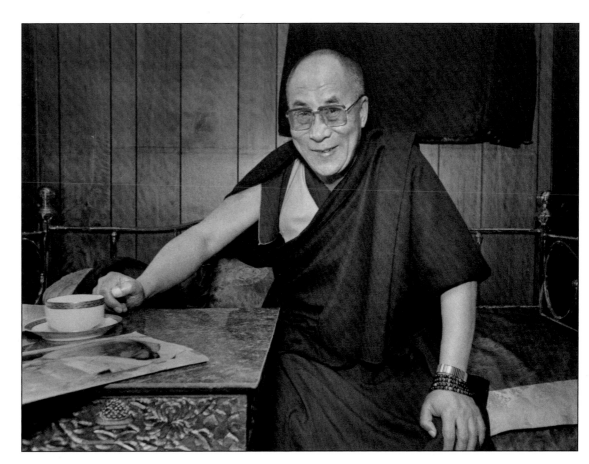

His Holiness, The Dalai Lama, 1993

Within the source of life
we are all expressions
of divine reality.

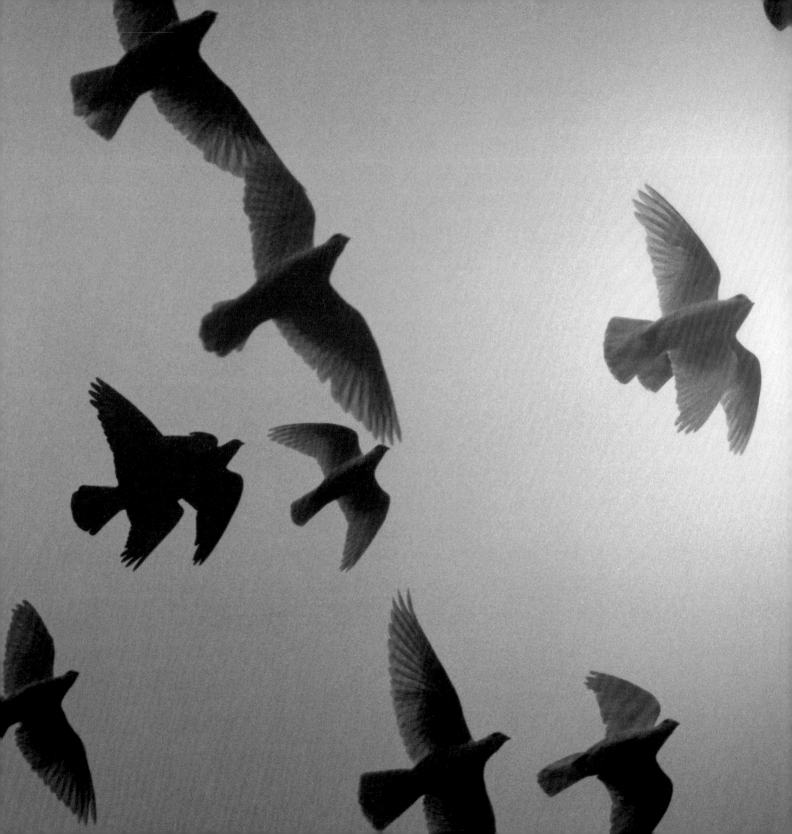

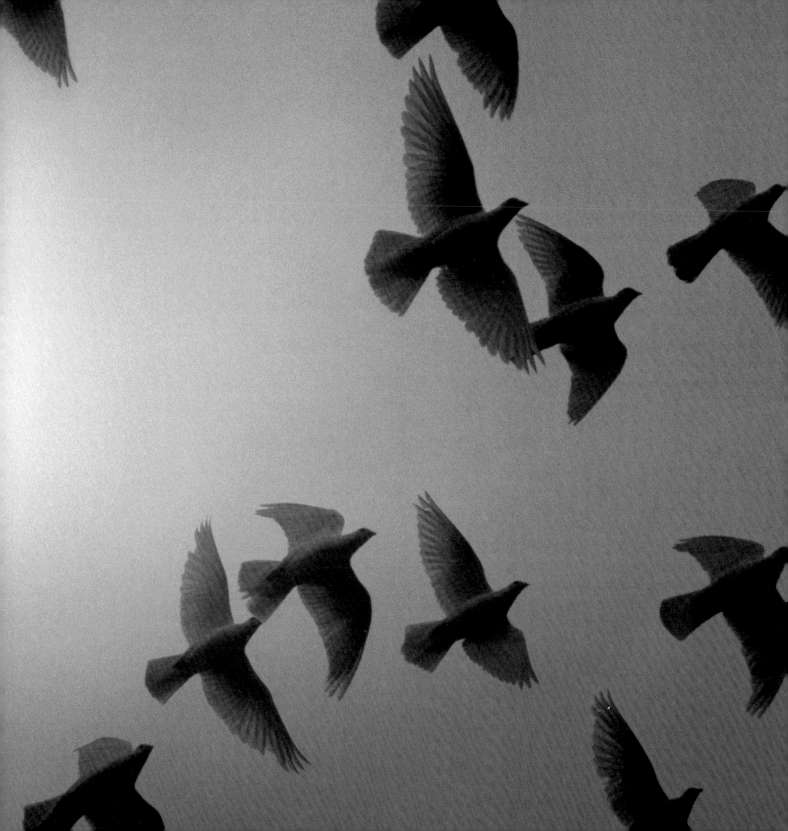

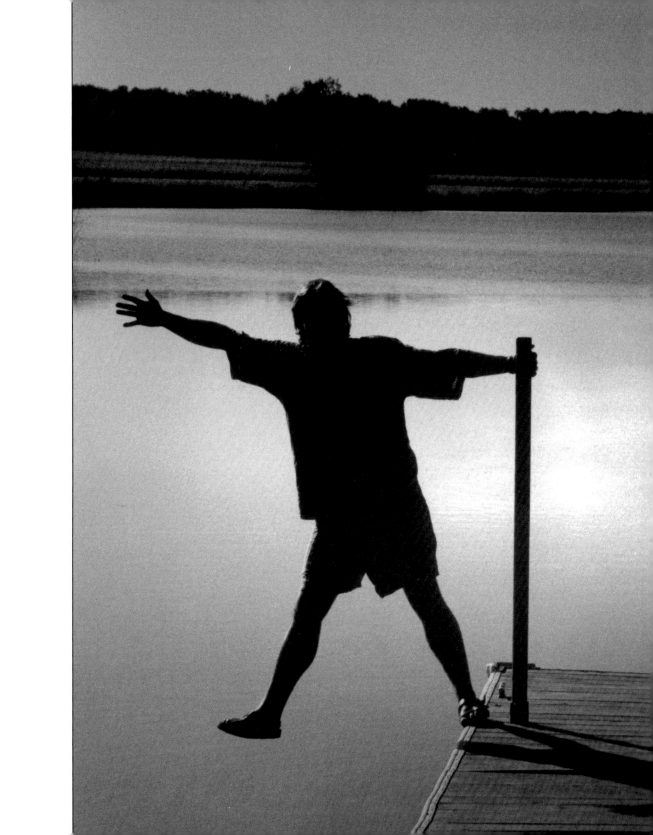

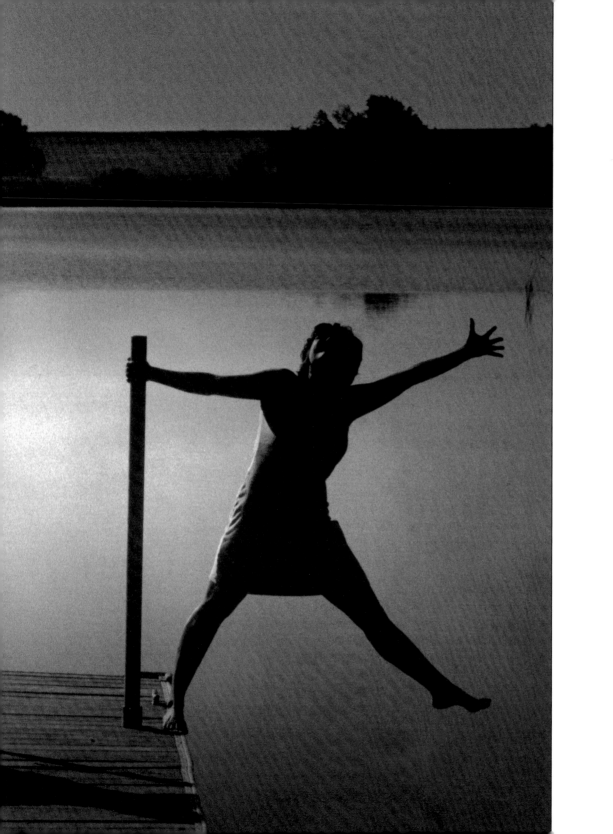

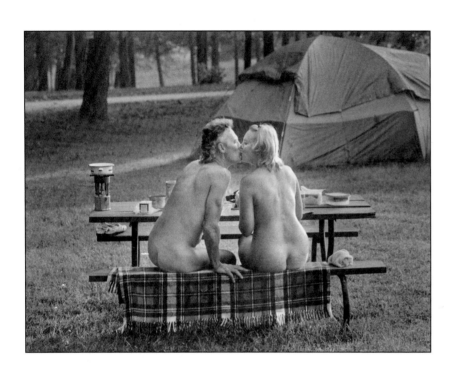

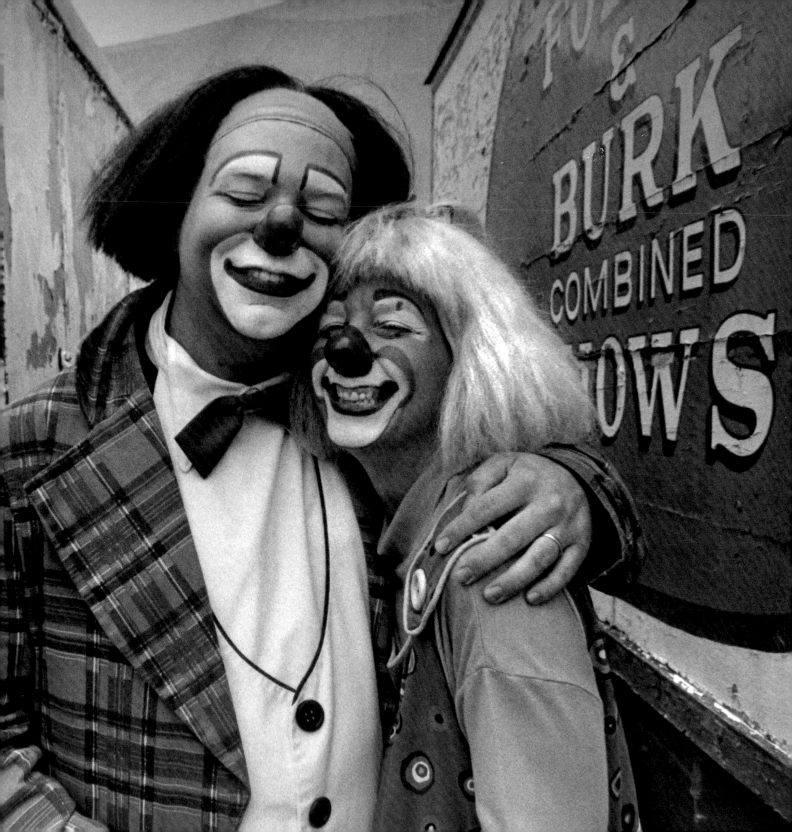

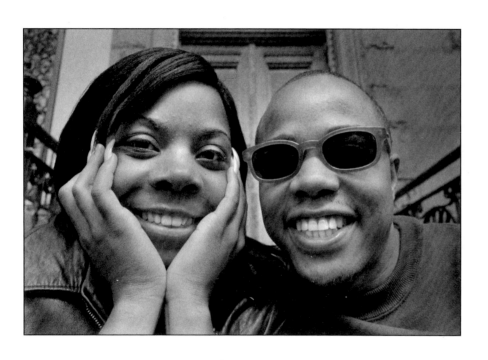

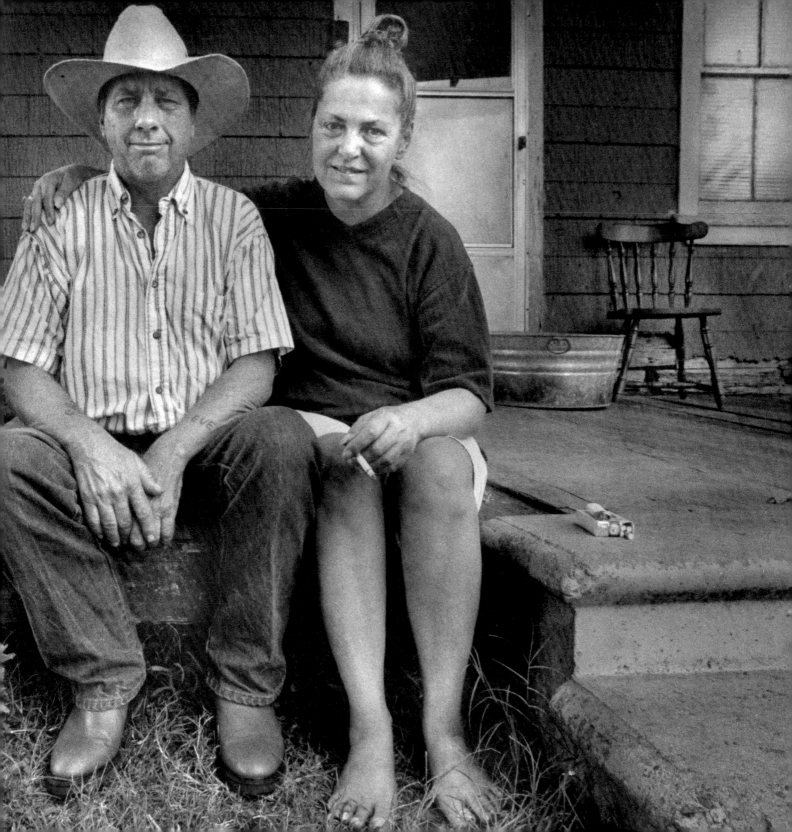

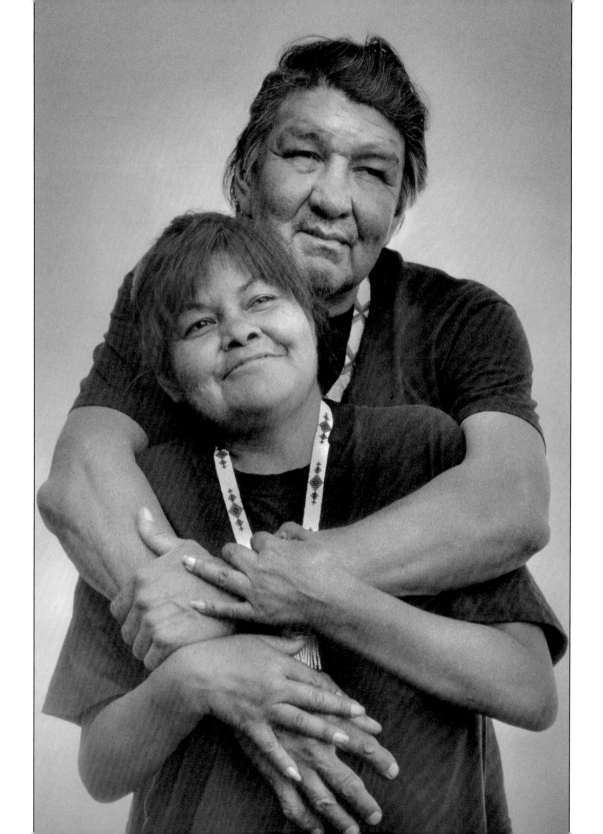

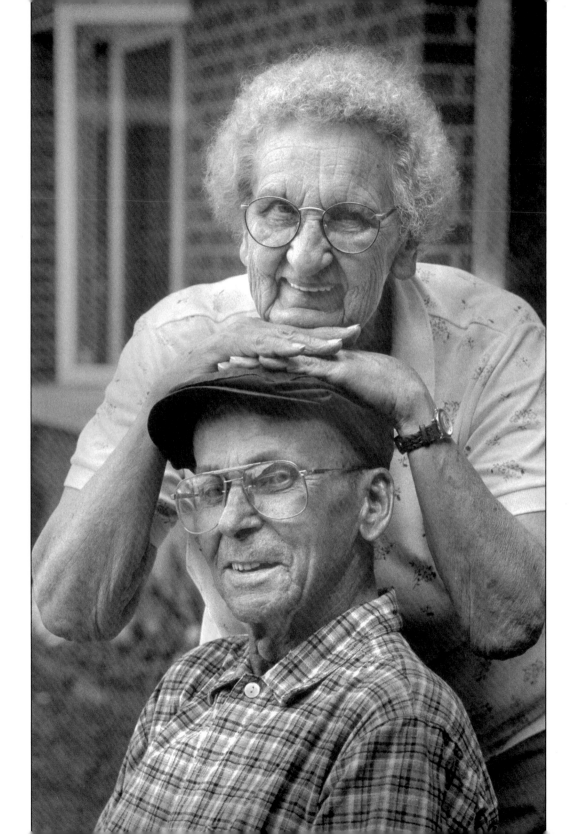

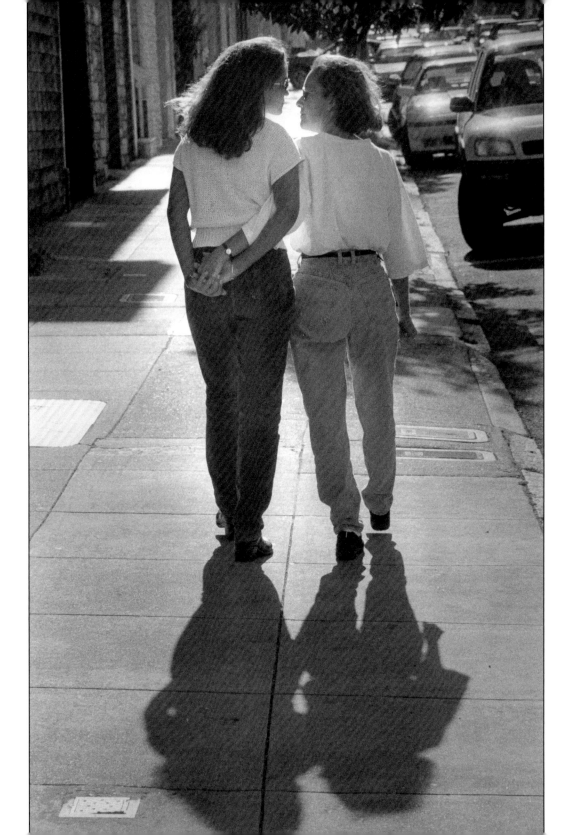

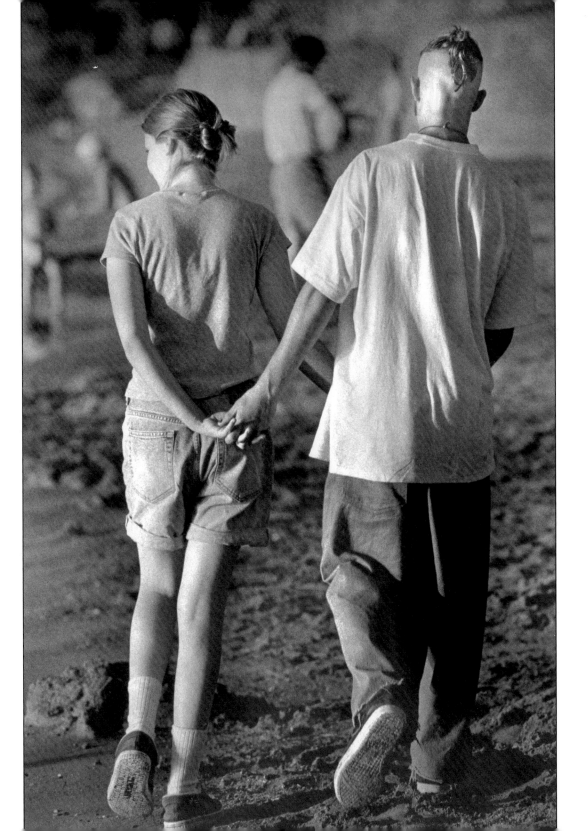

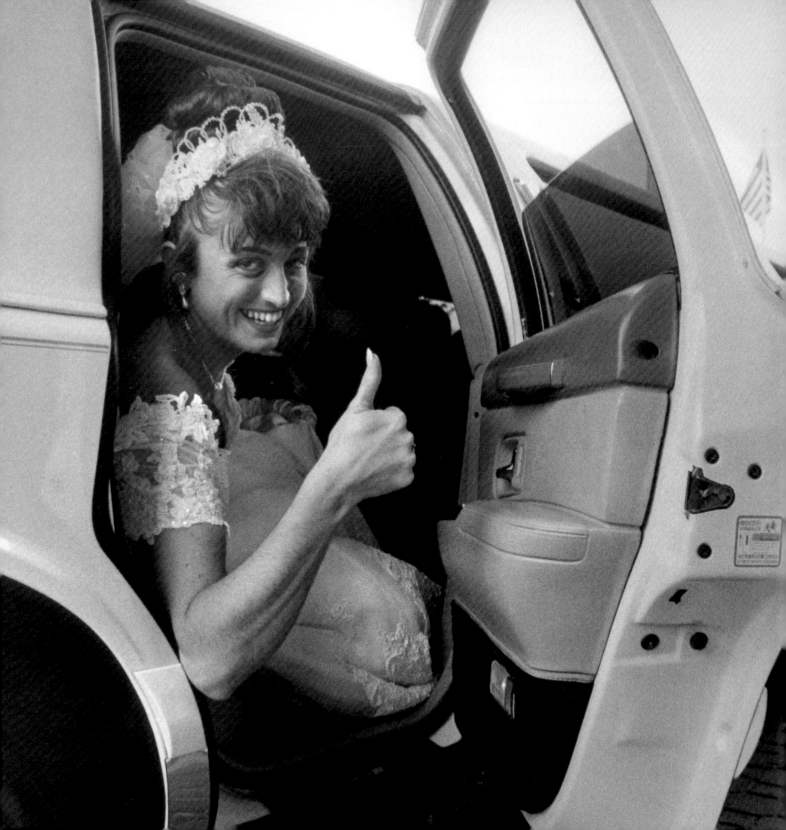

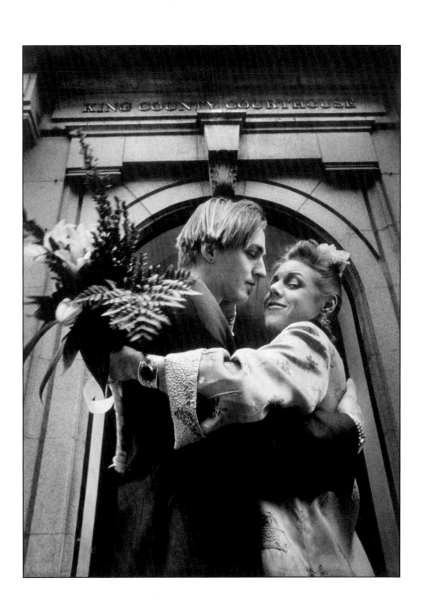

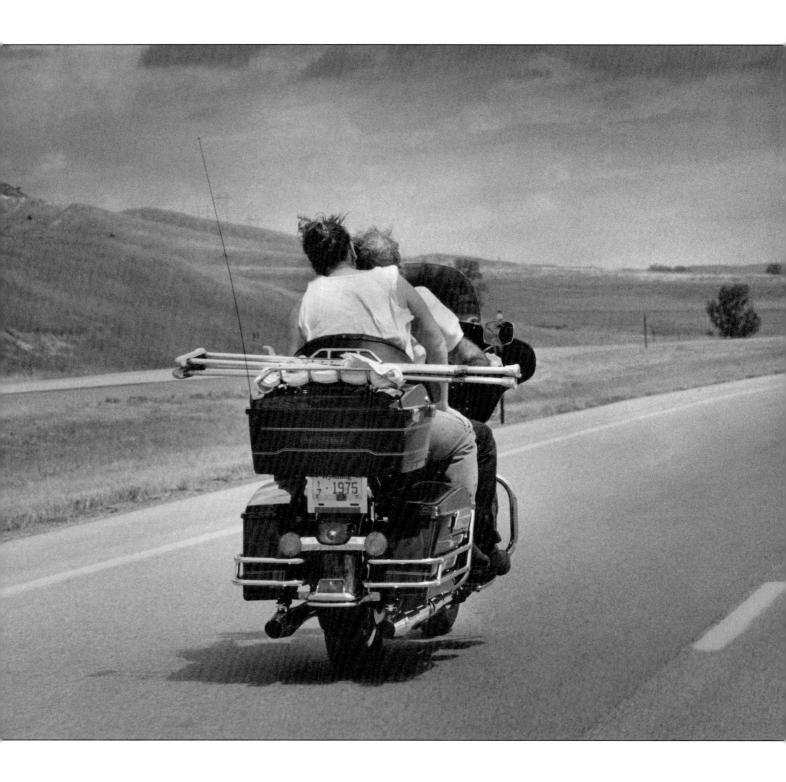

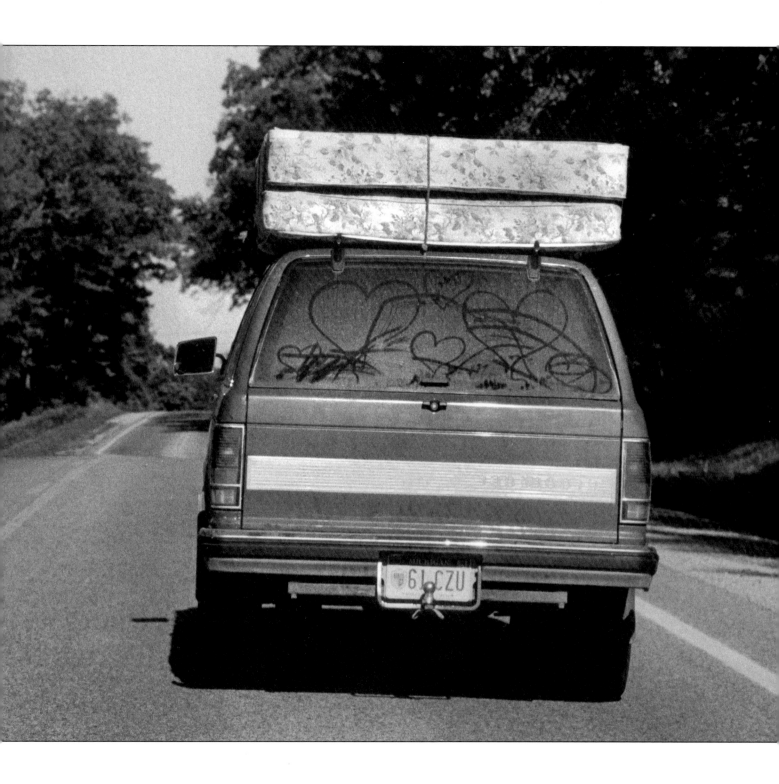

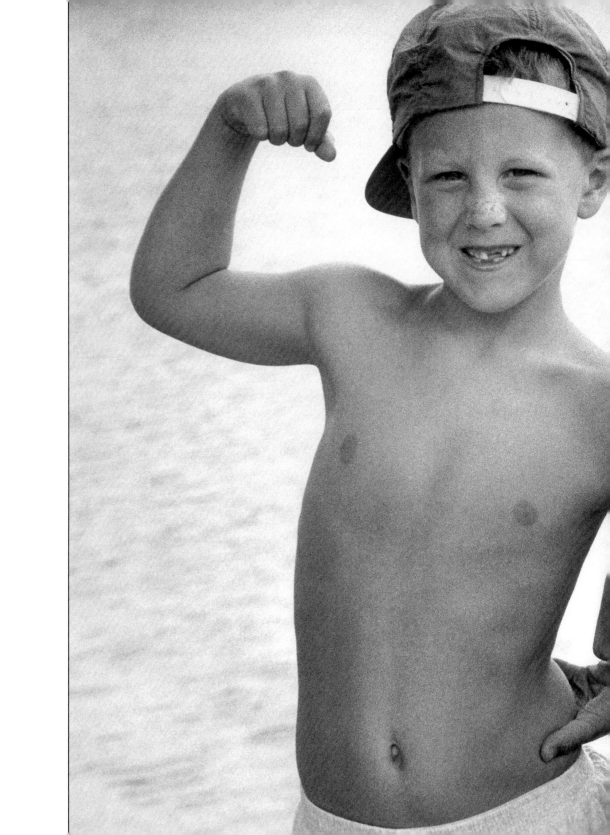

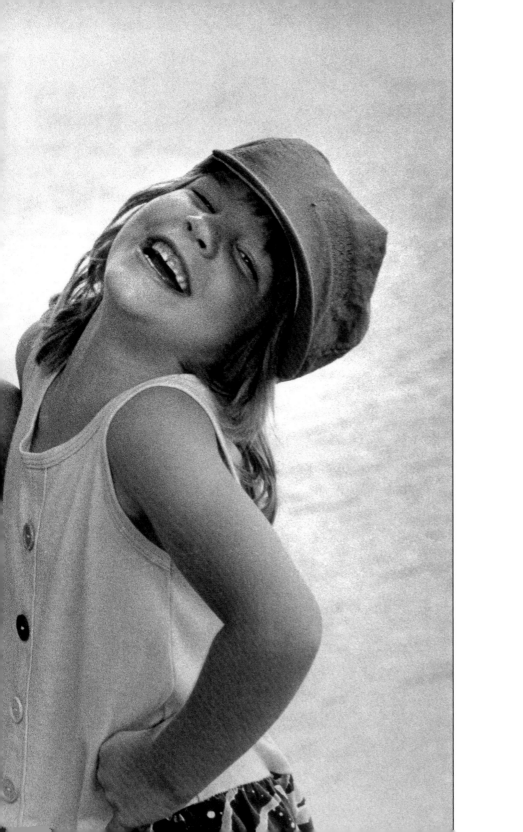

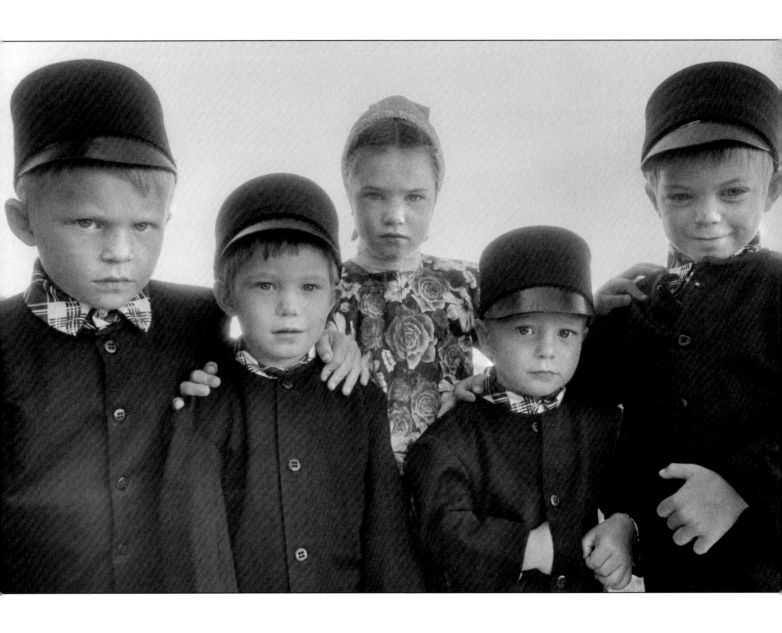

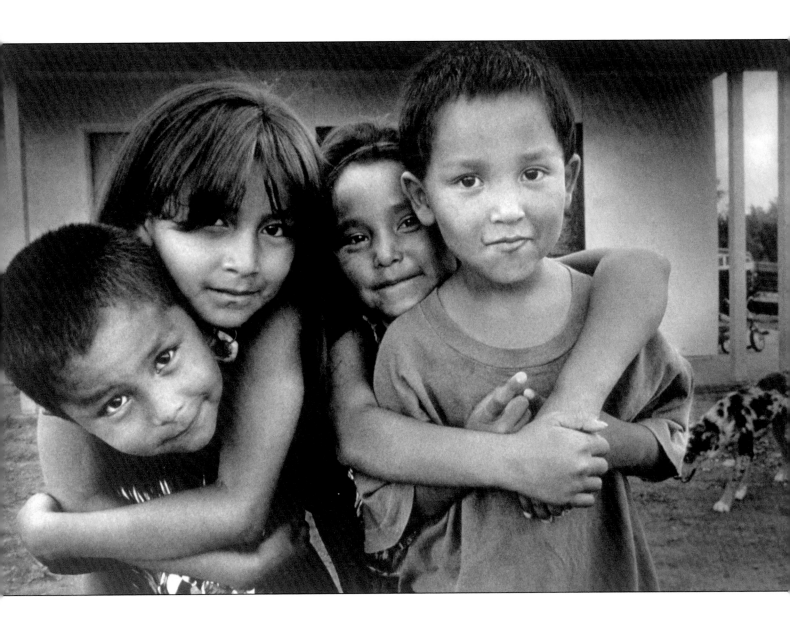

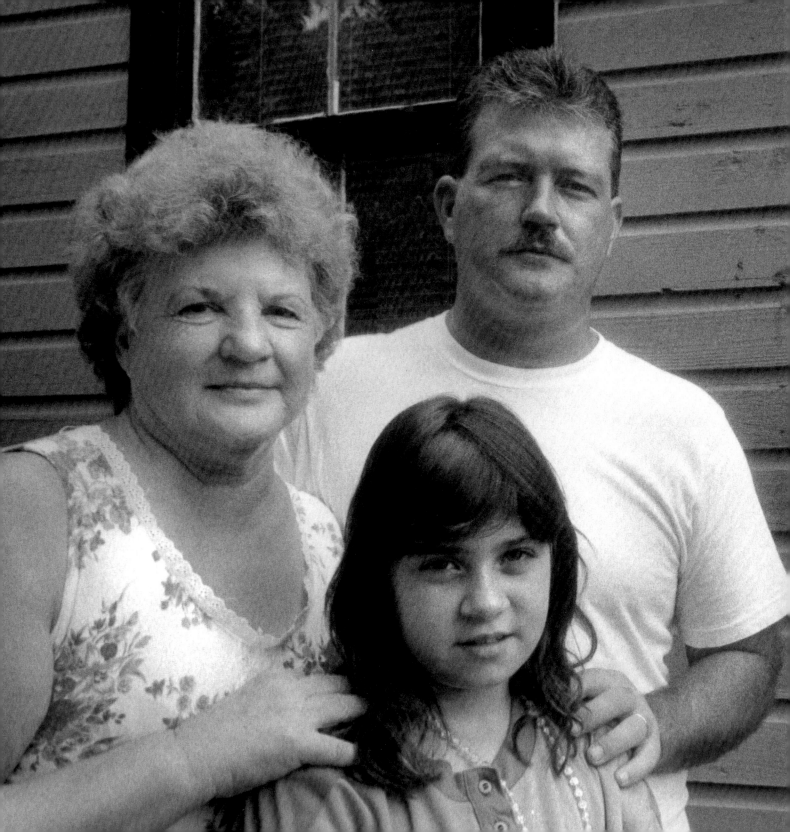

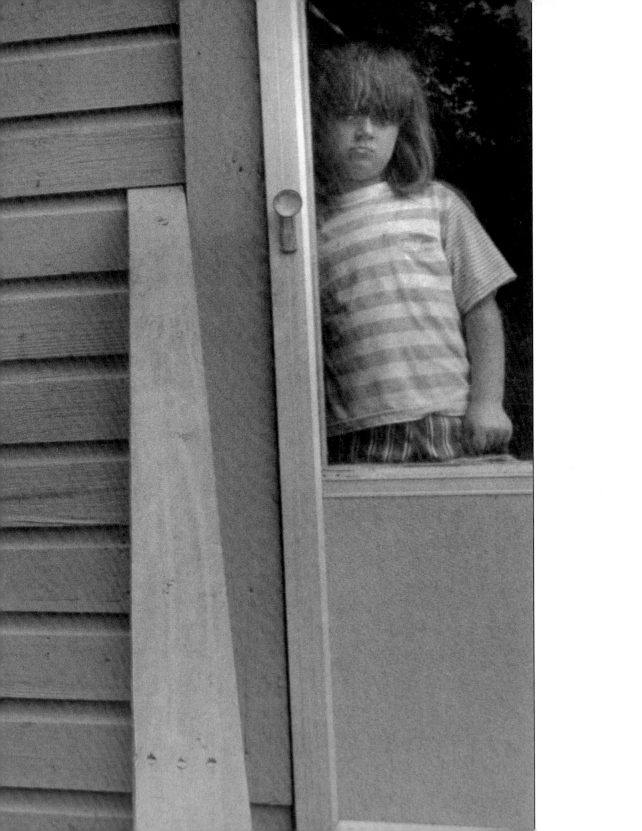

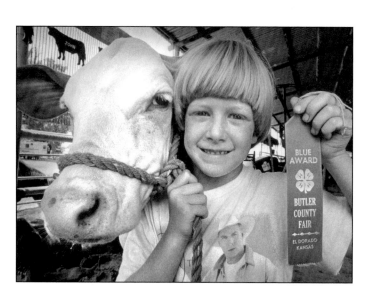

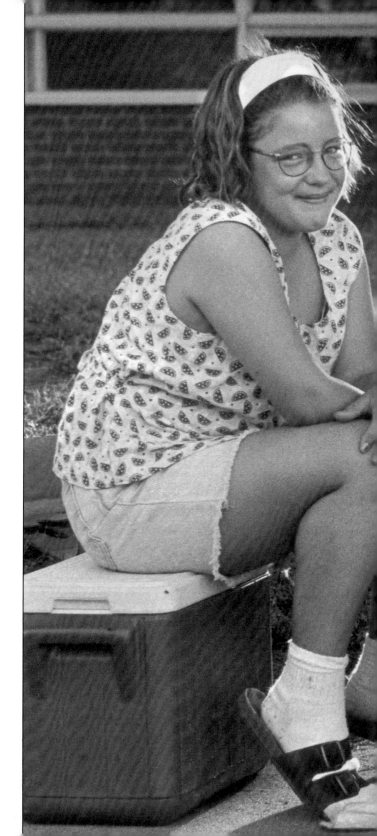

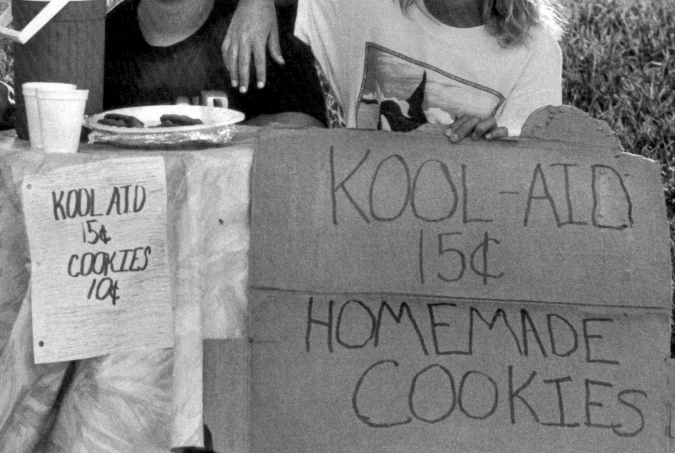

KOOL AID
15¢
COOKIES
10¢

KOOL-AID
15¢
HOMEMADE
COOKIES

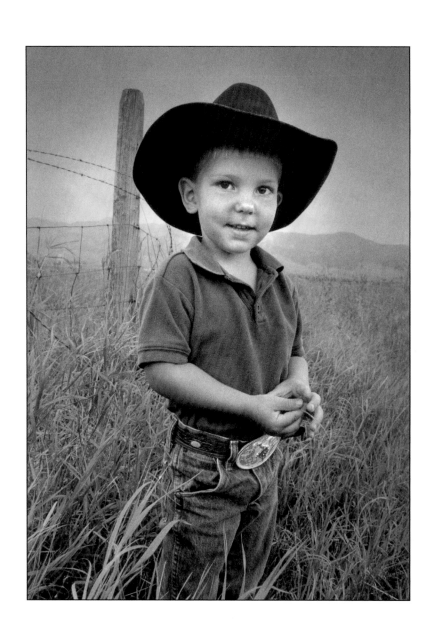

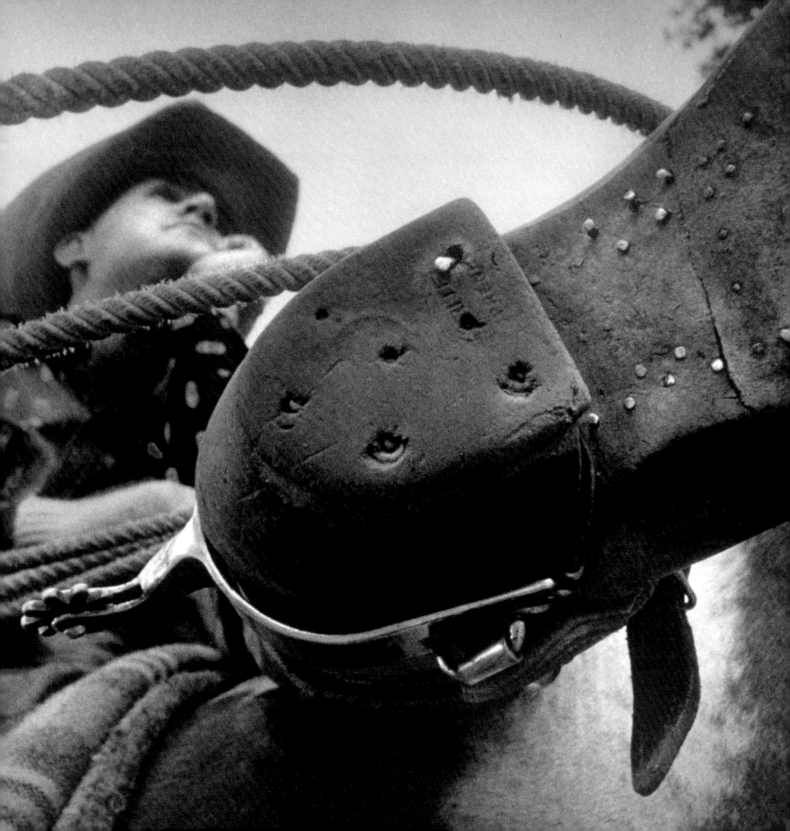

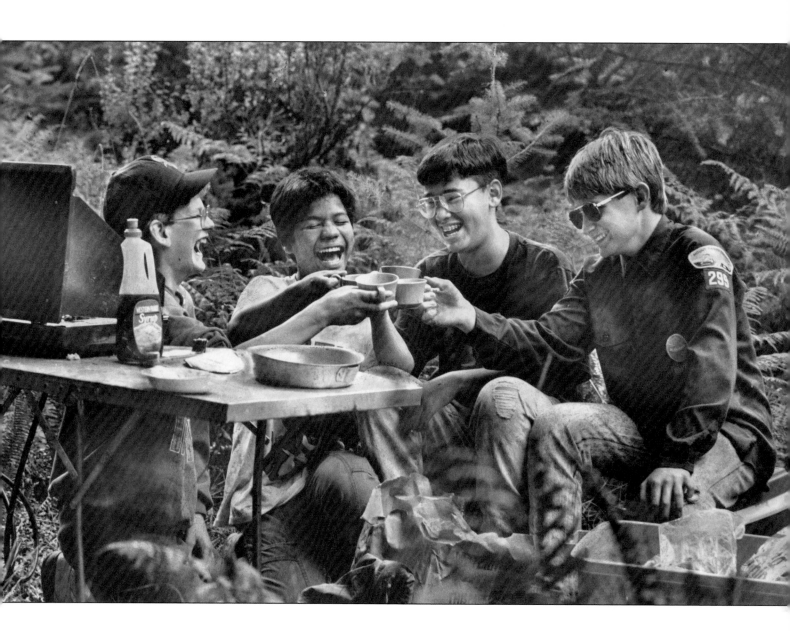

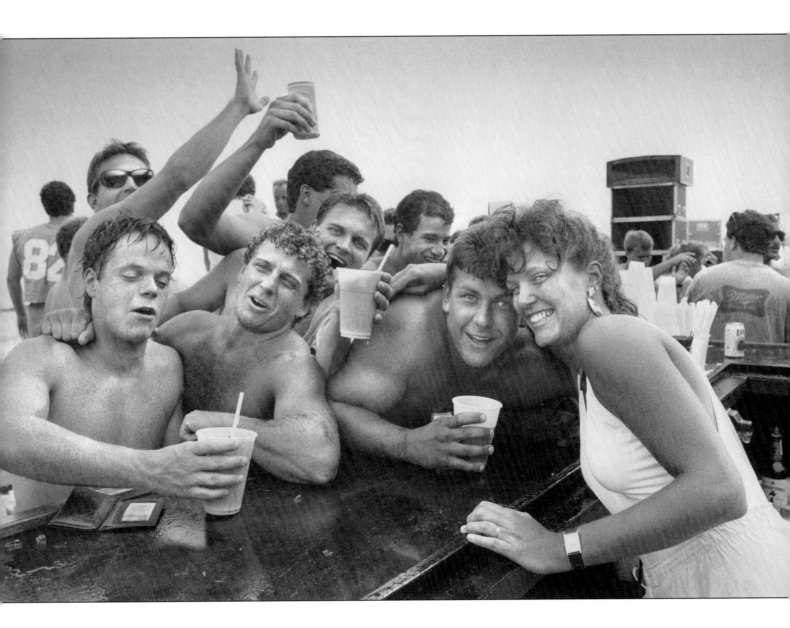

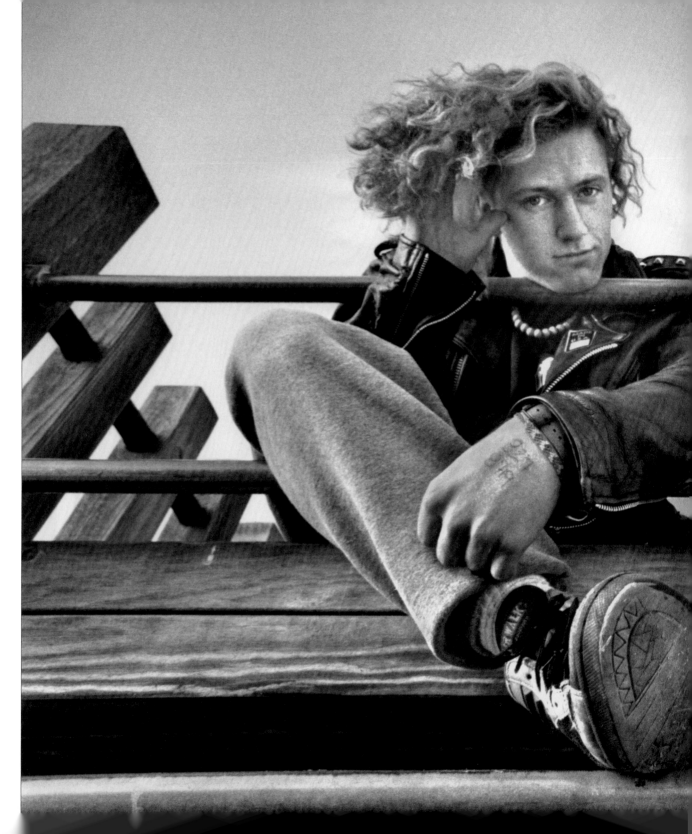

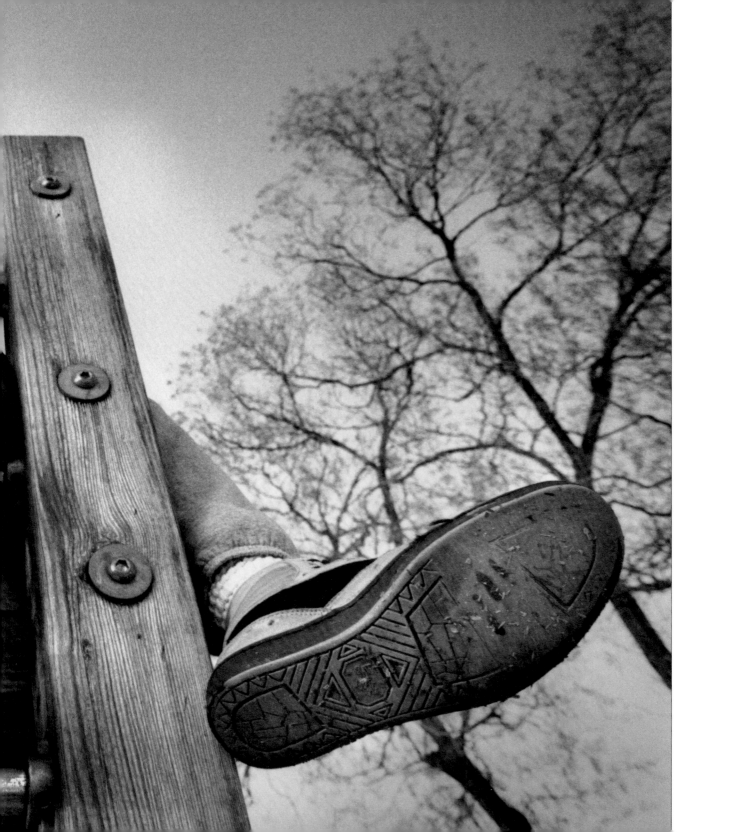

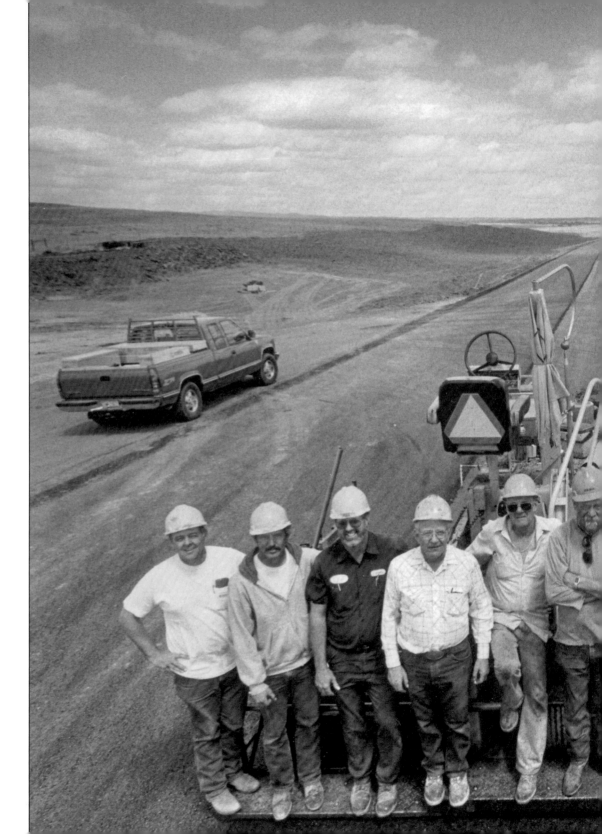

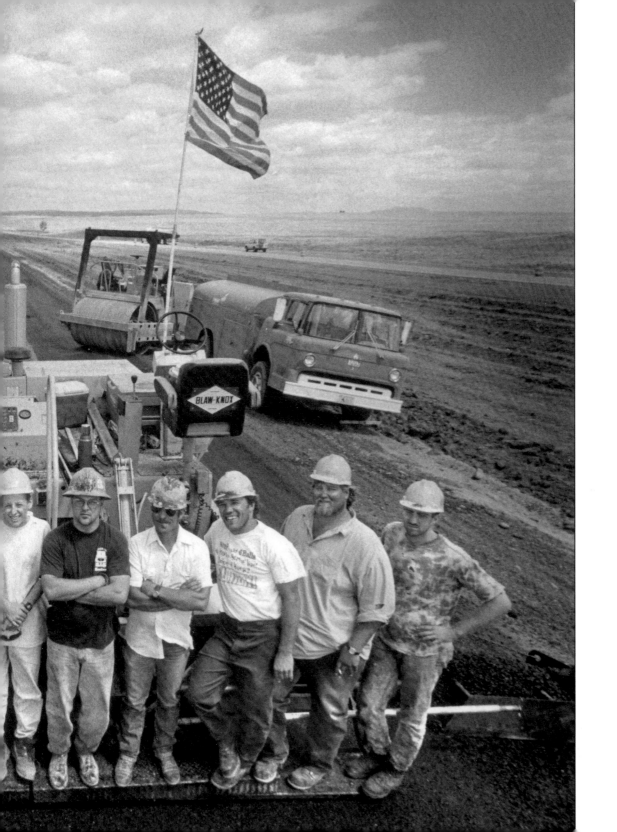

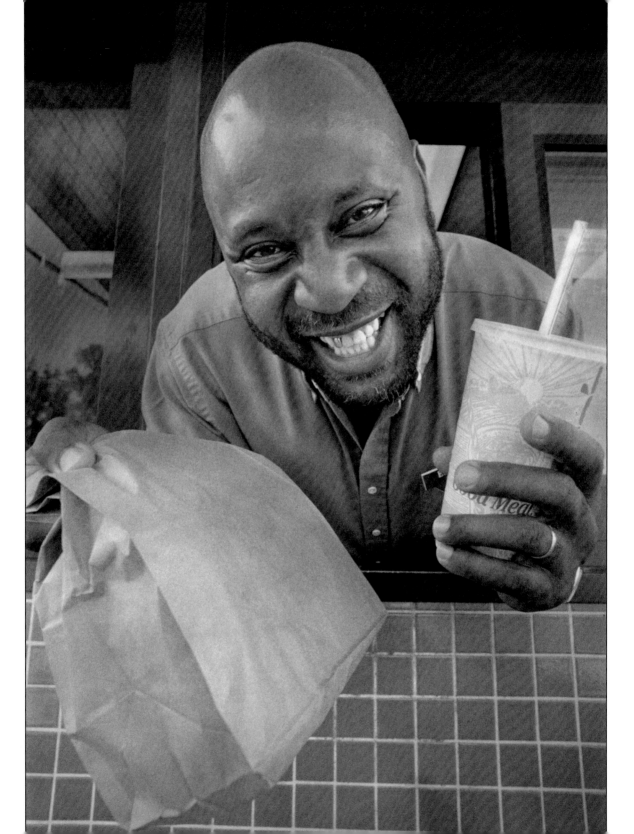

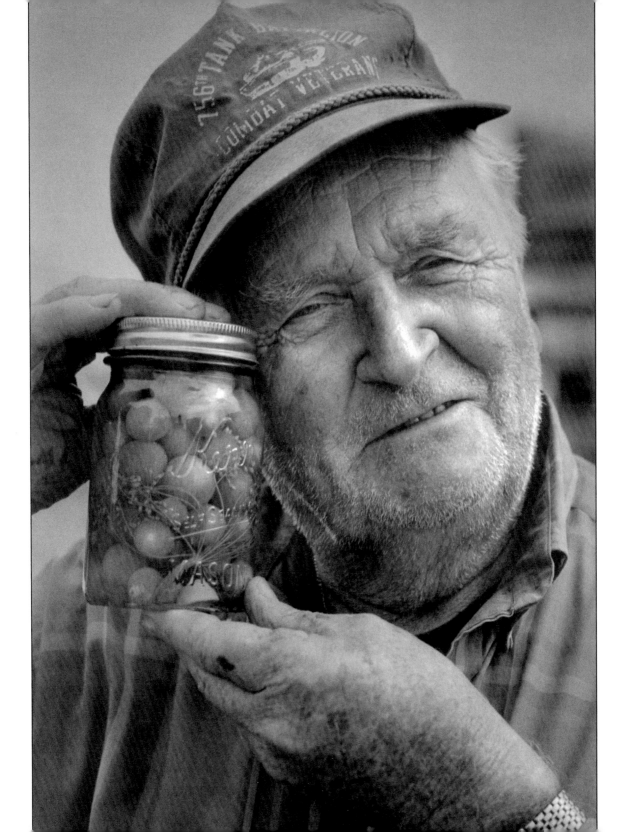

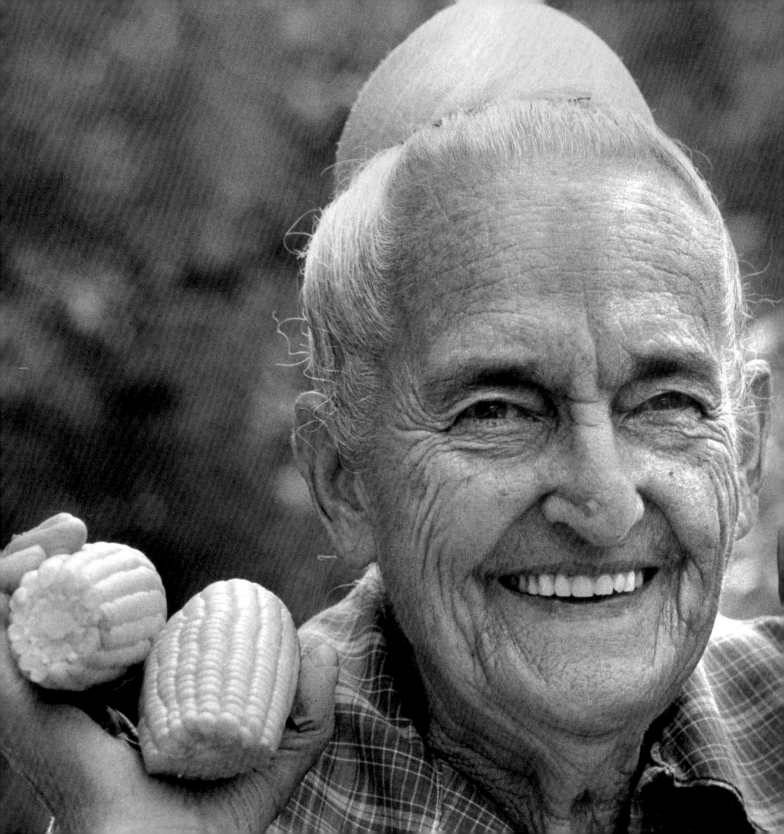

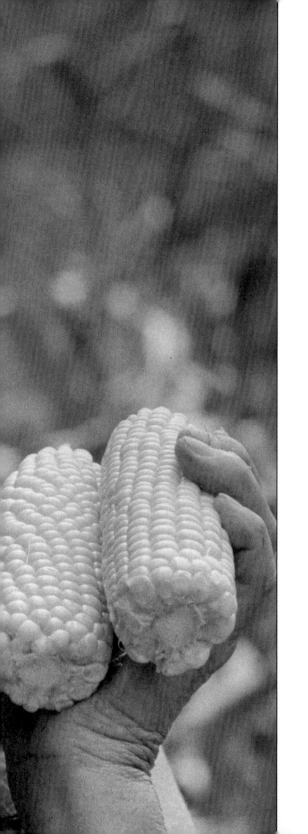
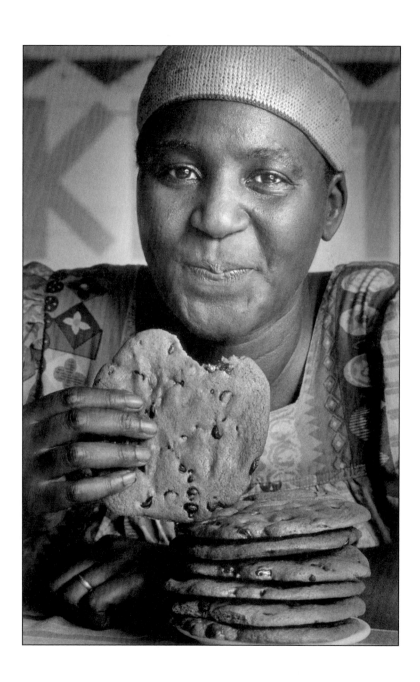

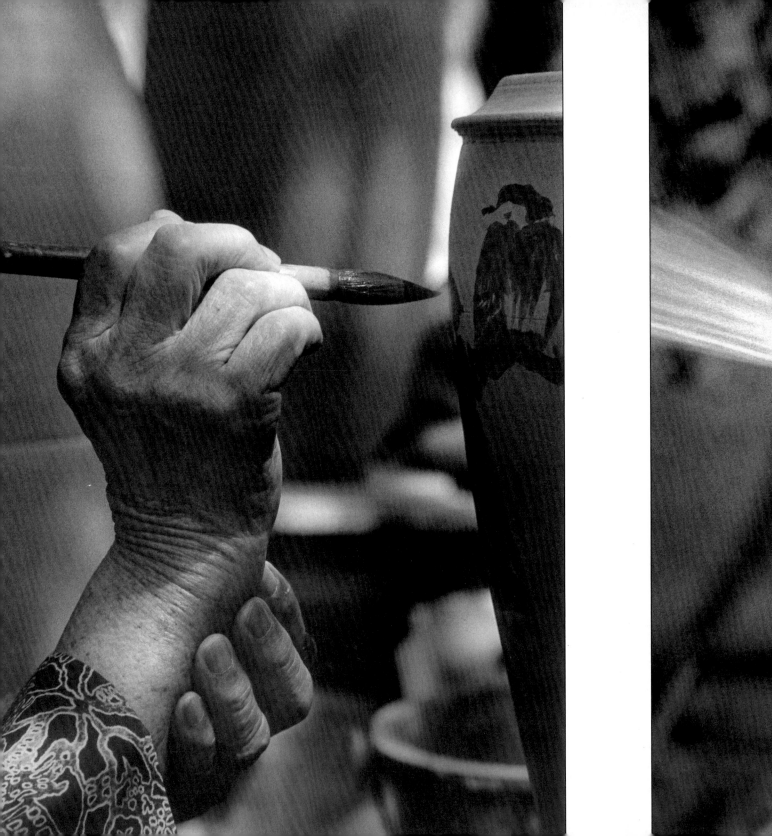

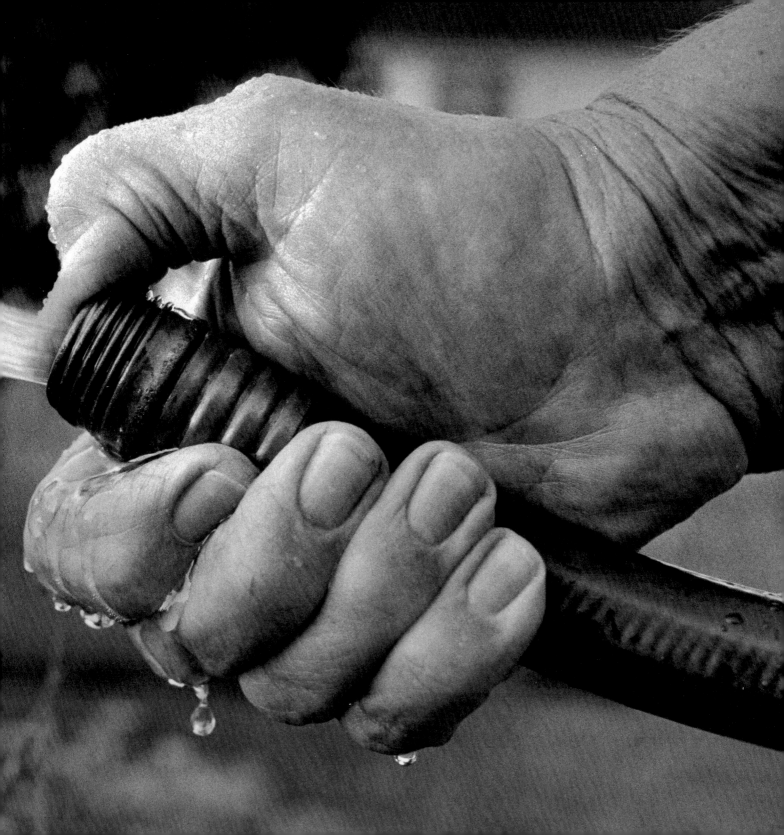

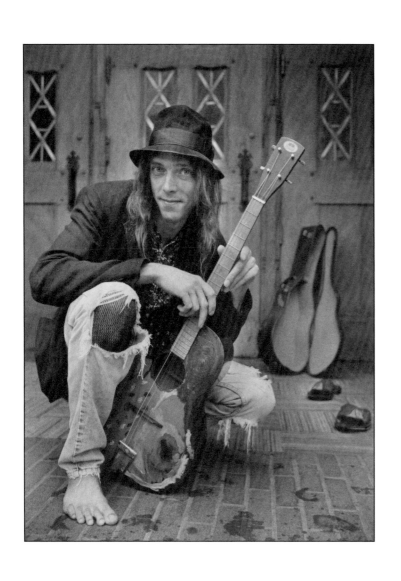

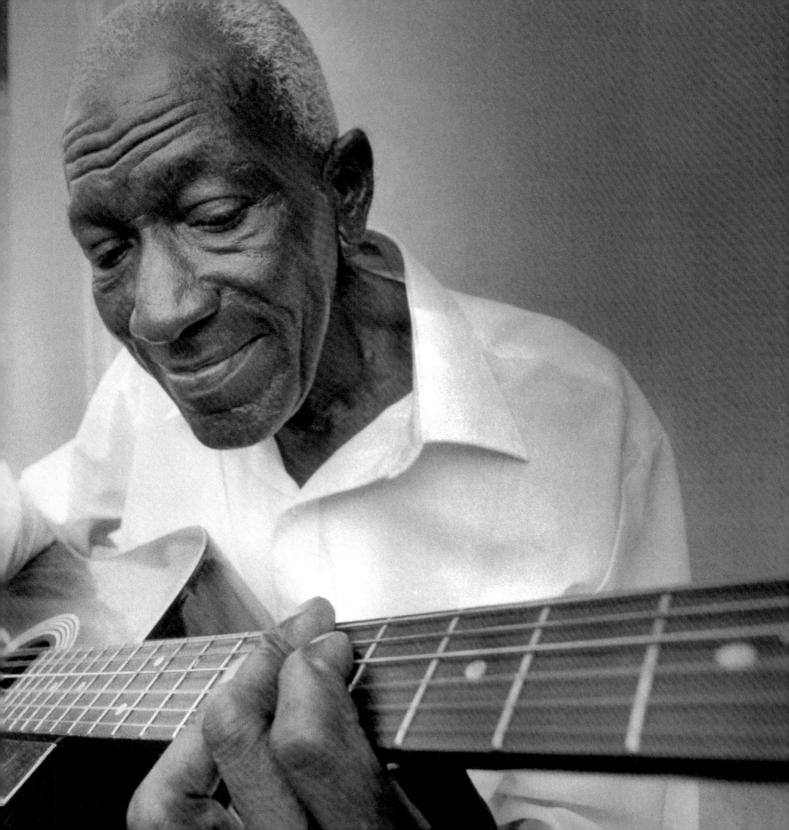

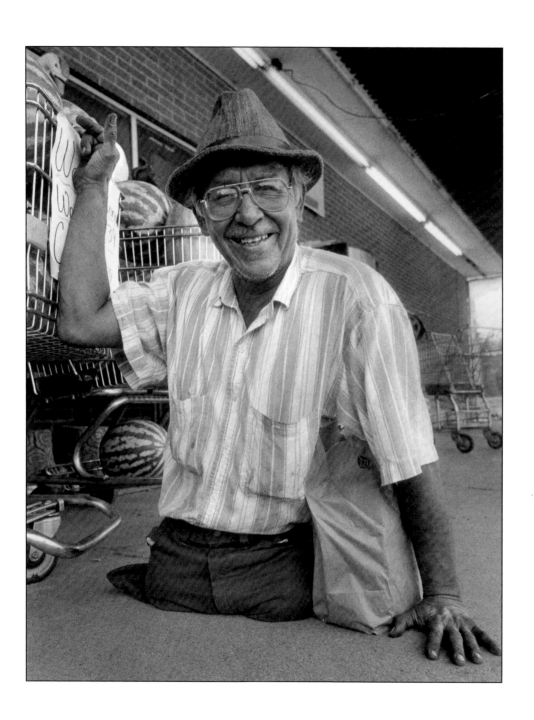

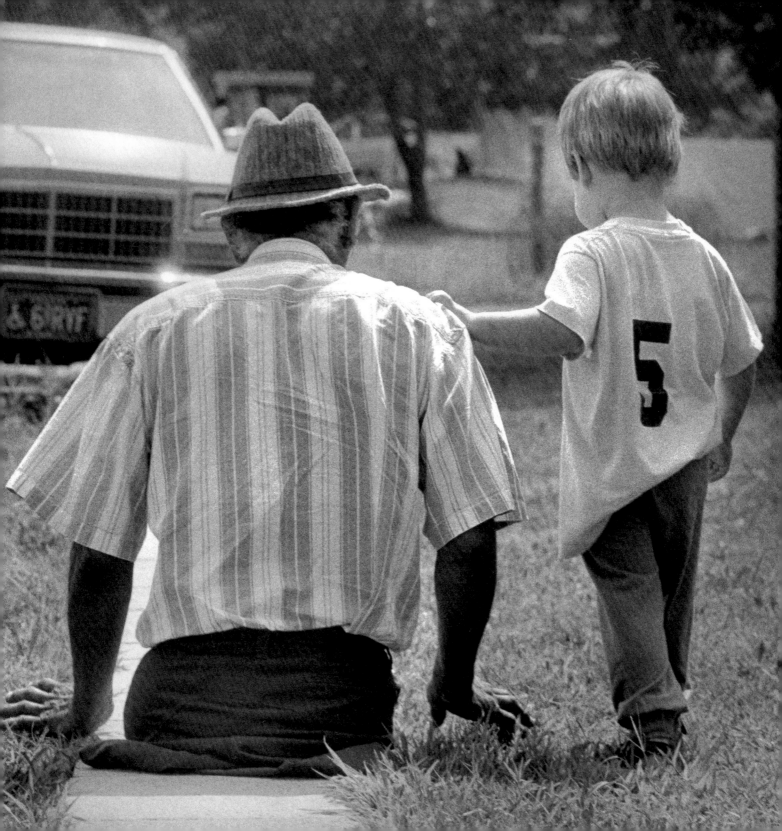

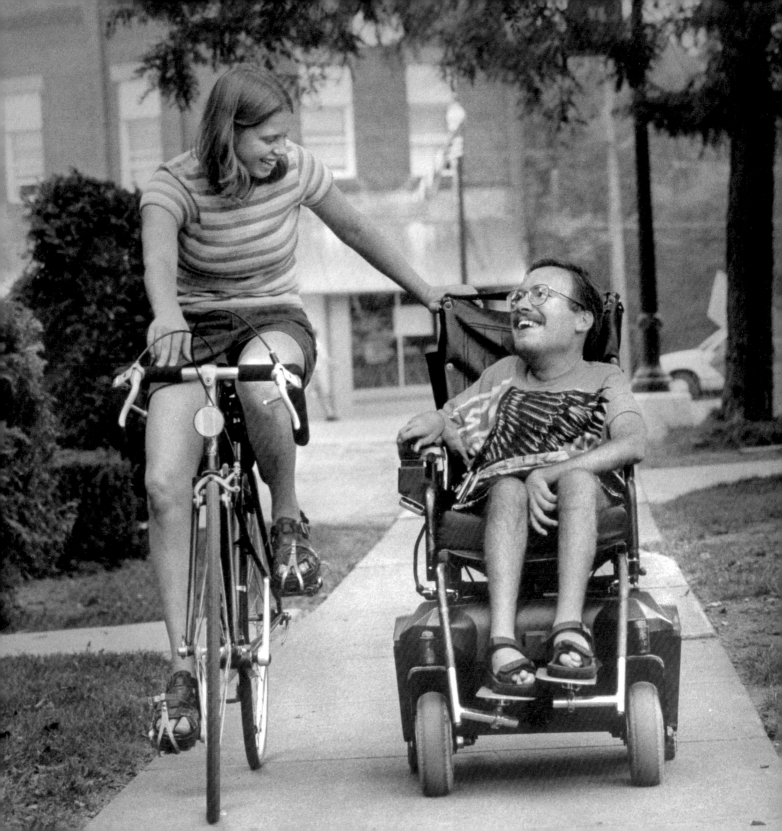

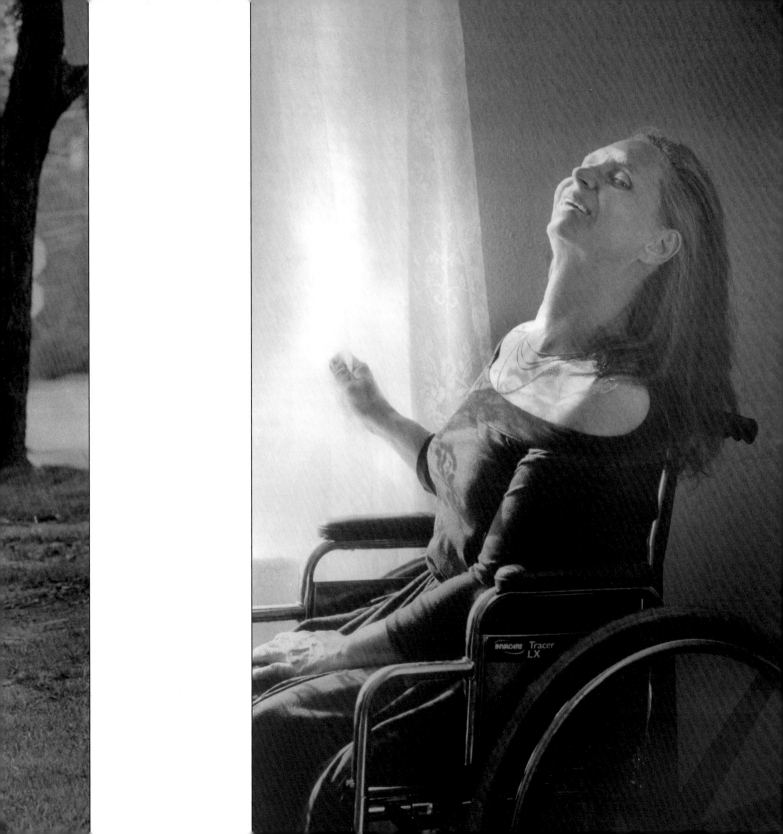

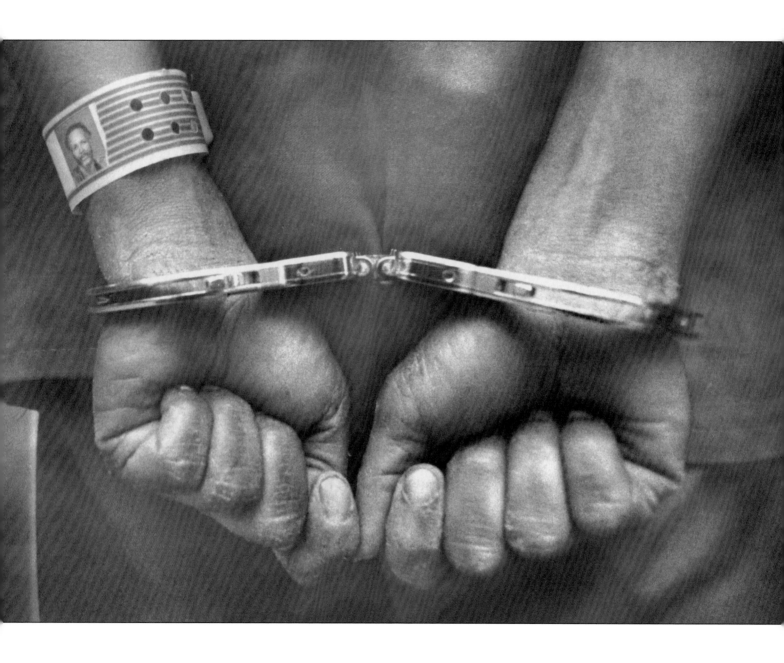

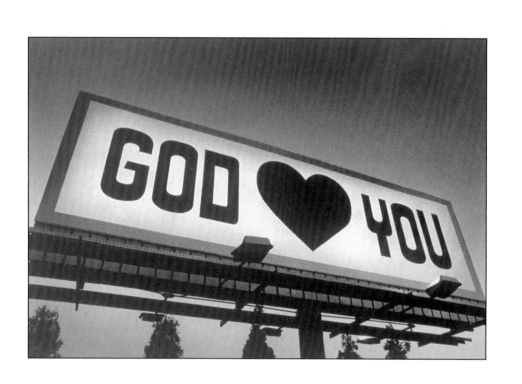

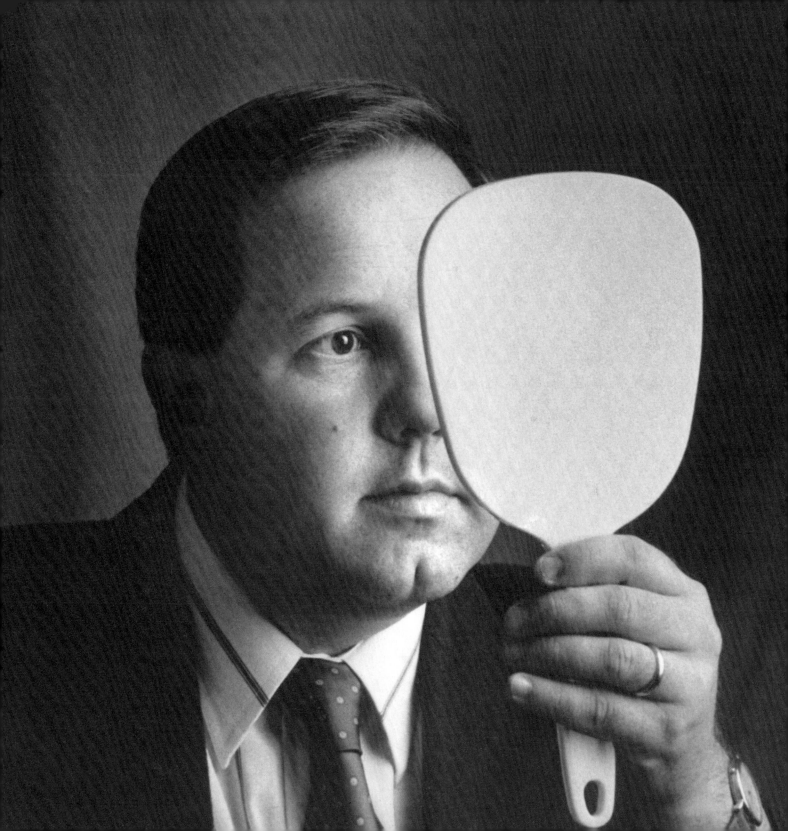

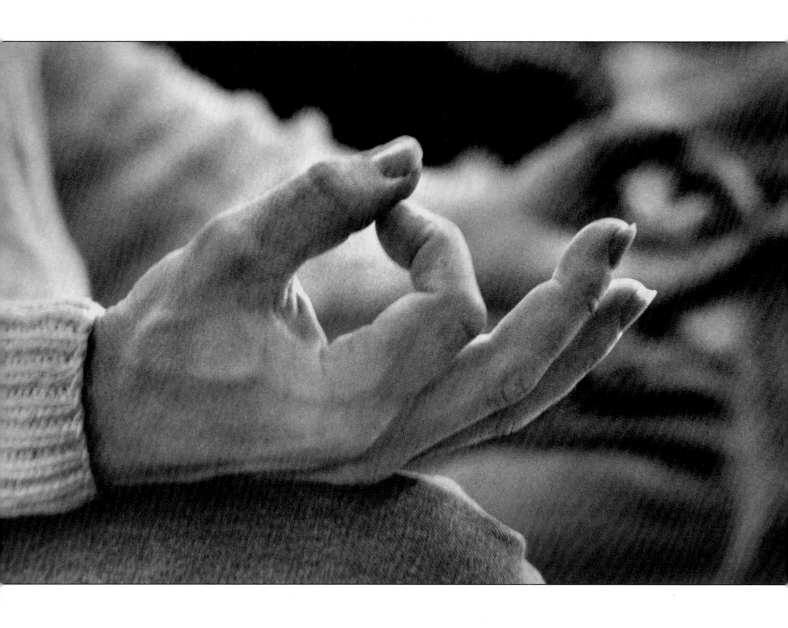

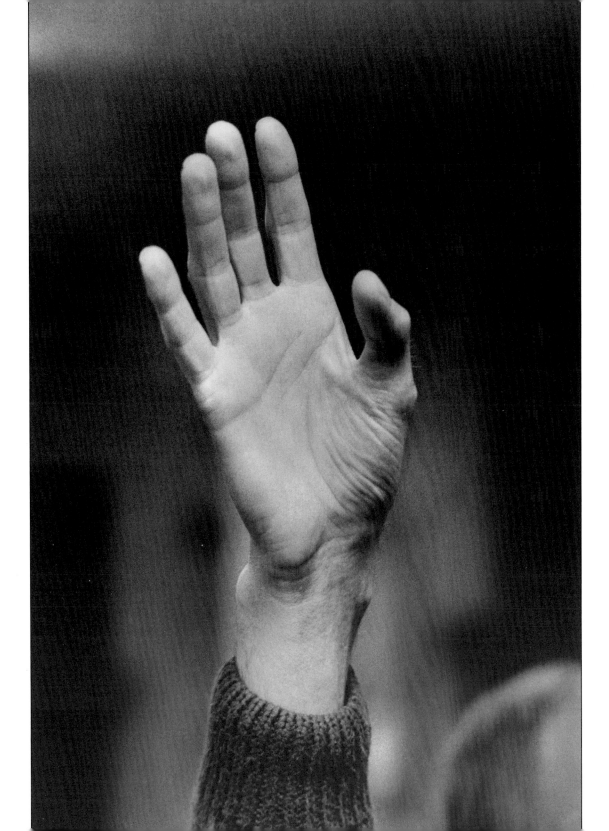

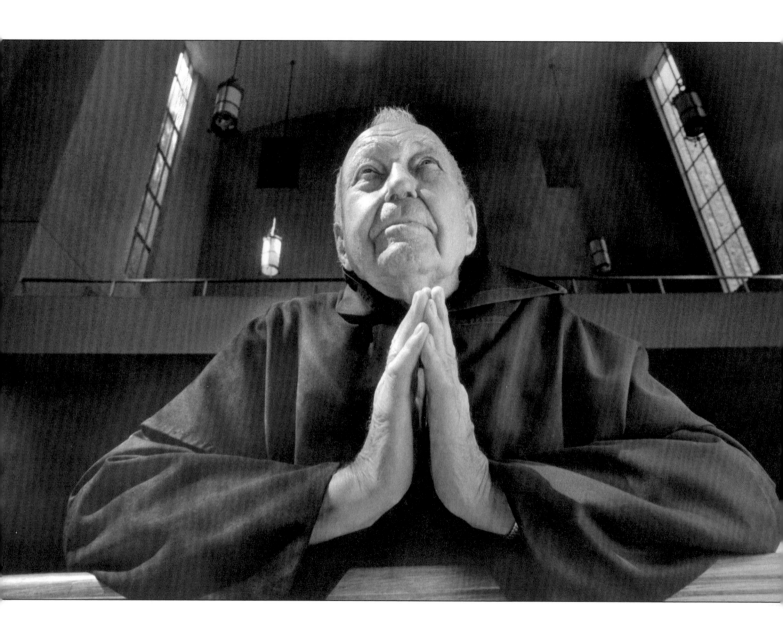

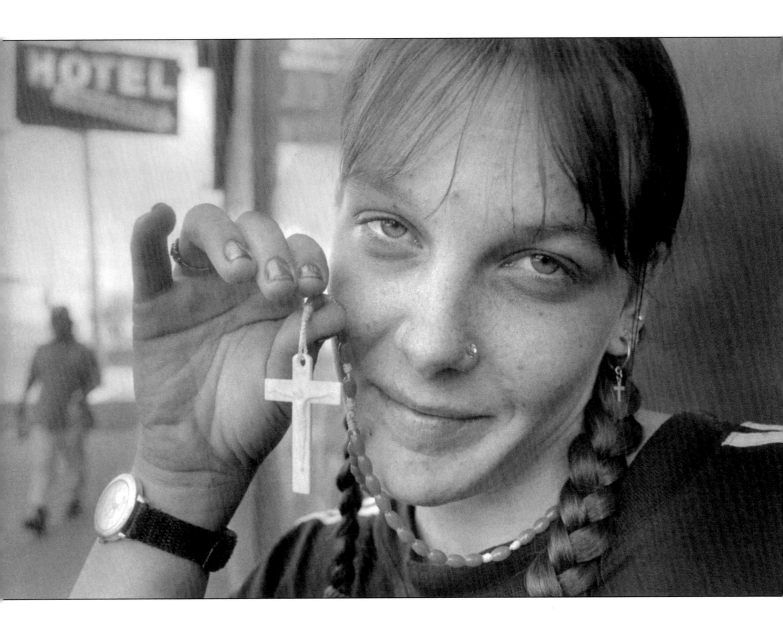

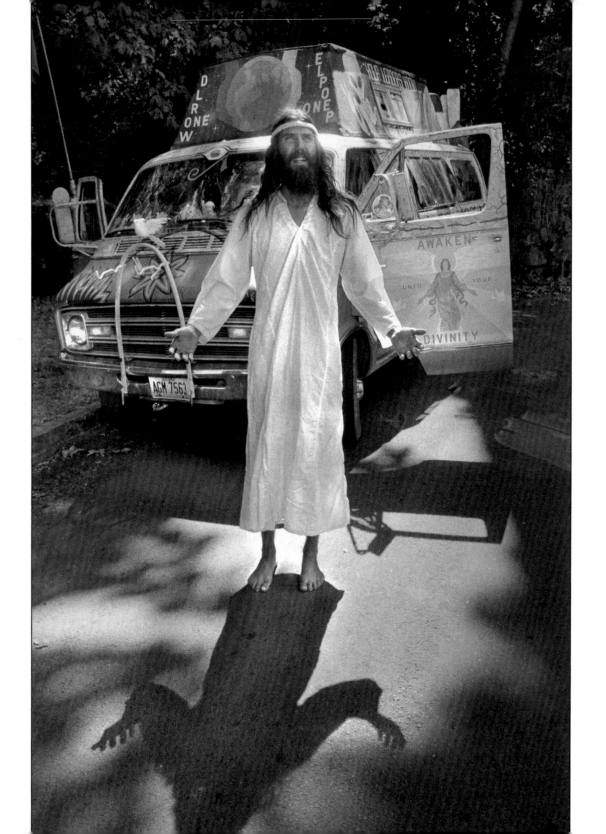

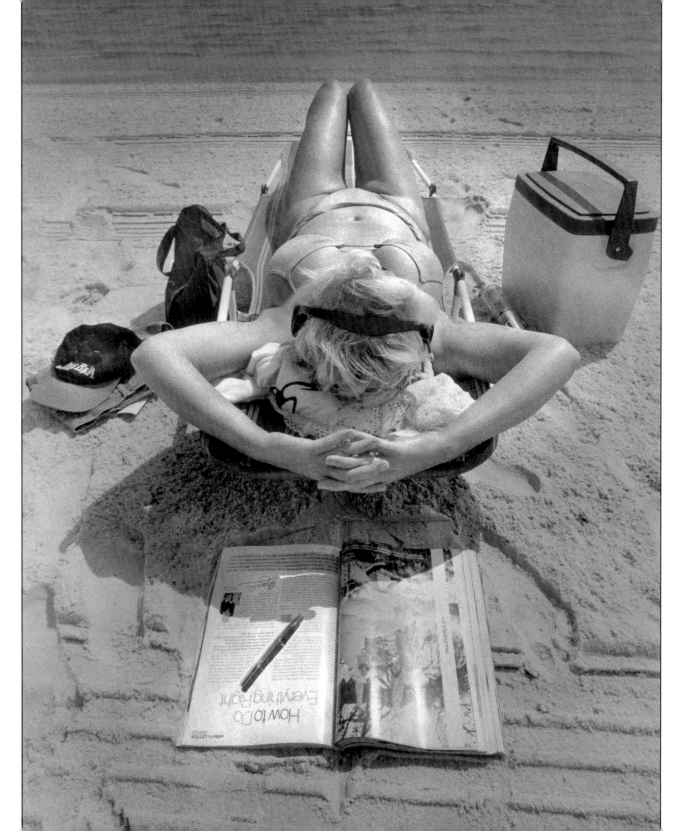

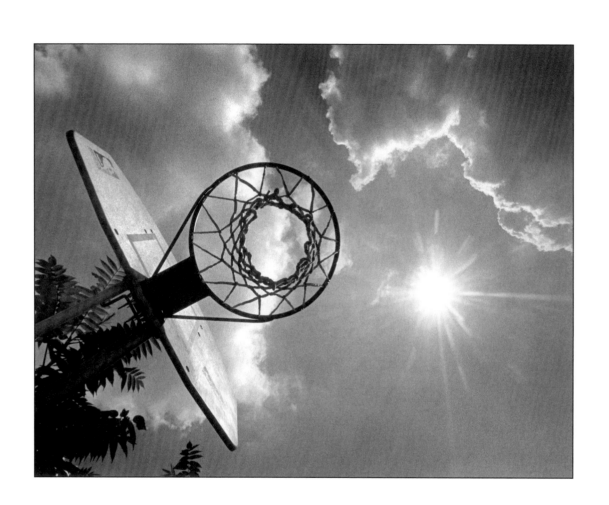

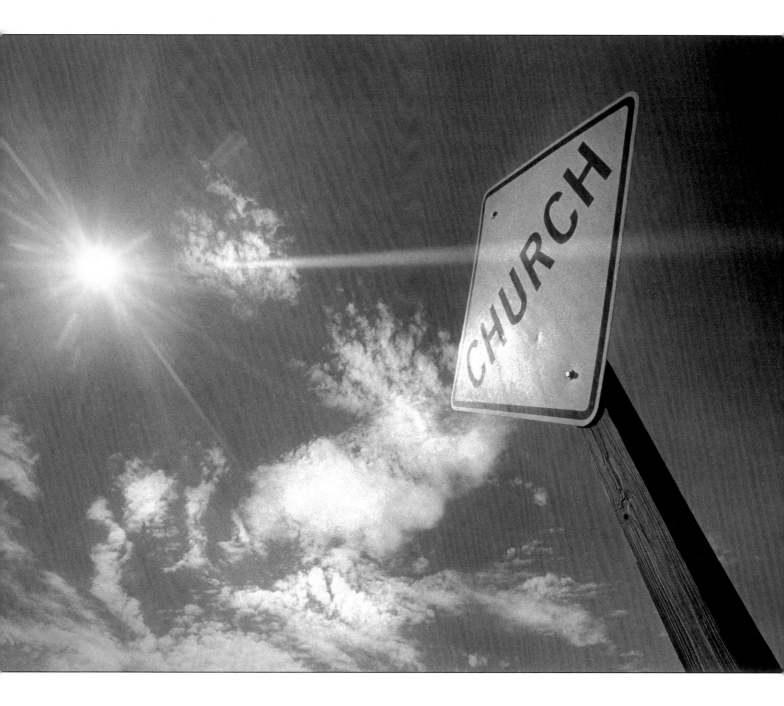

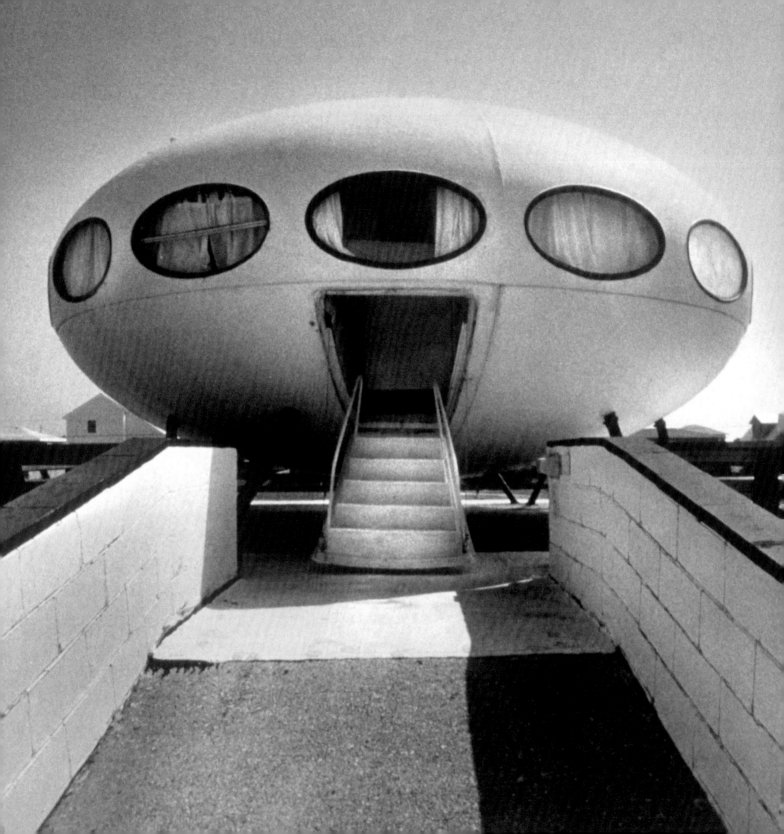

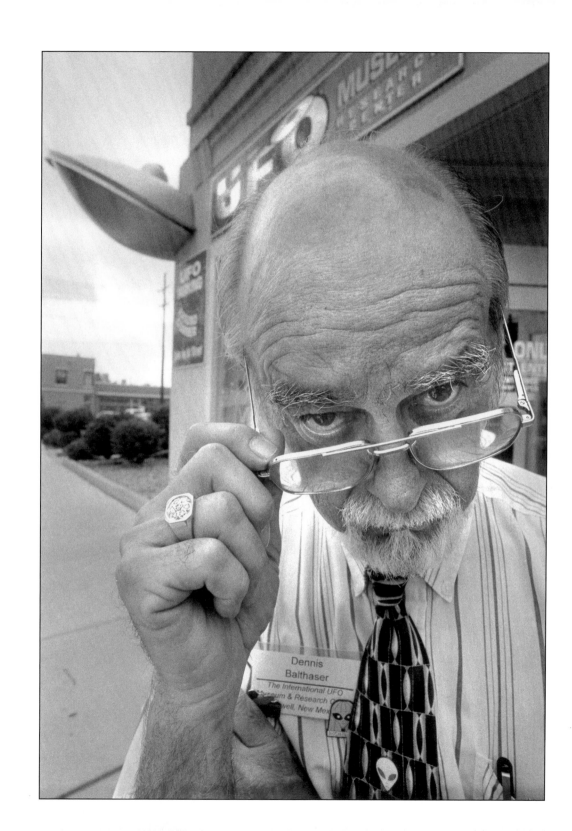

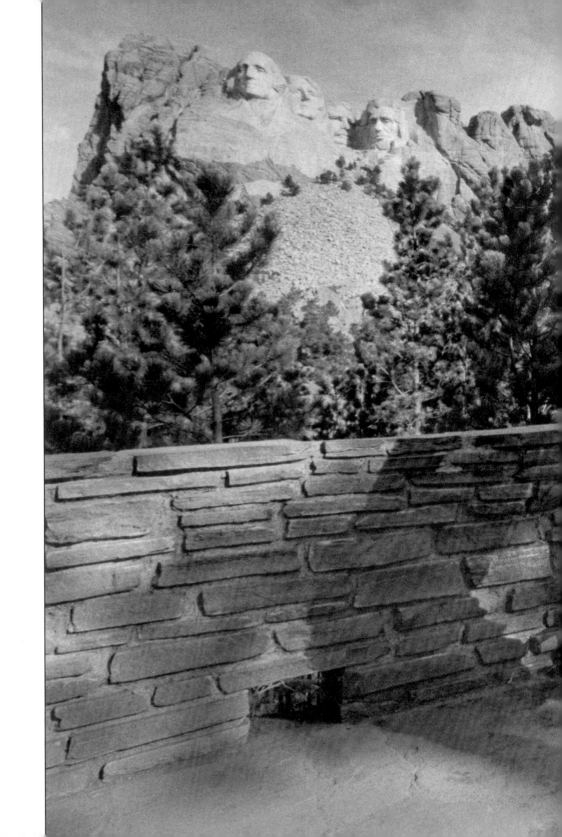

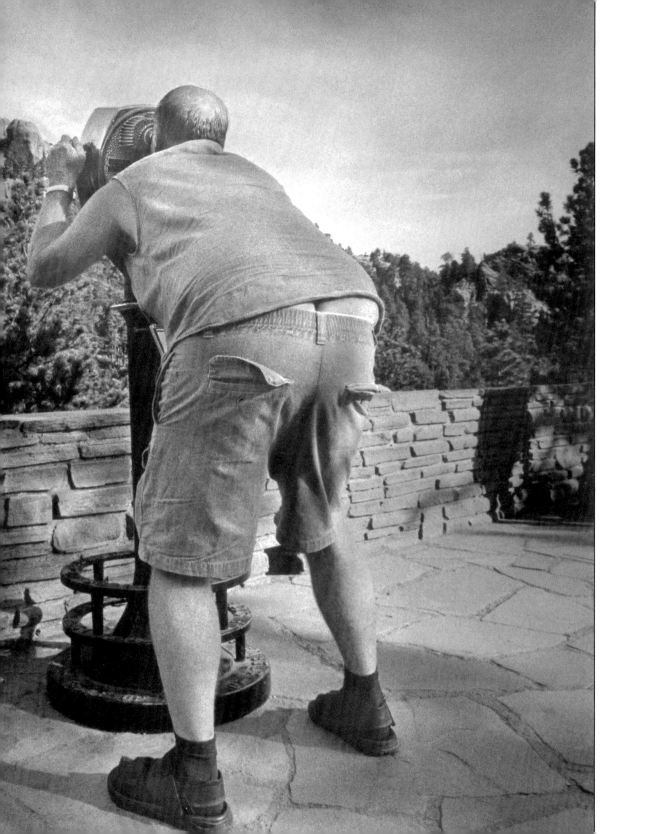

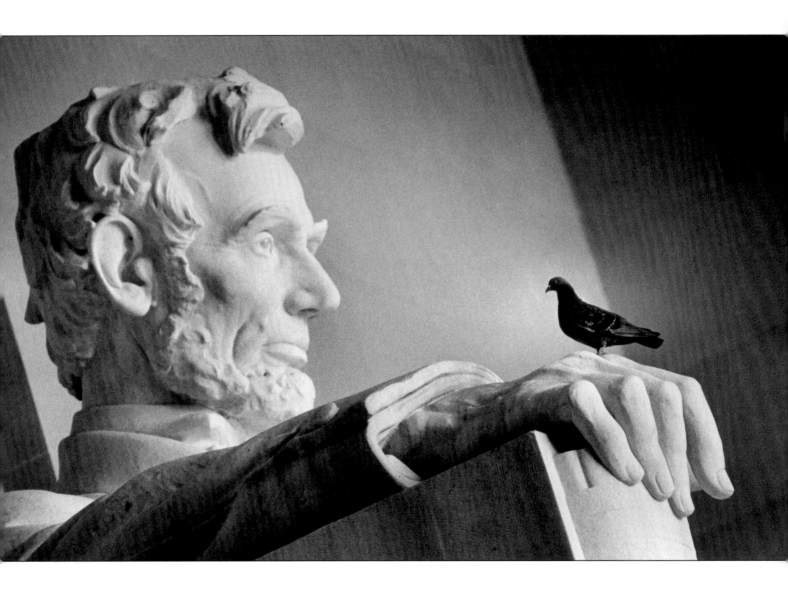

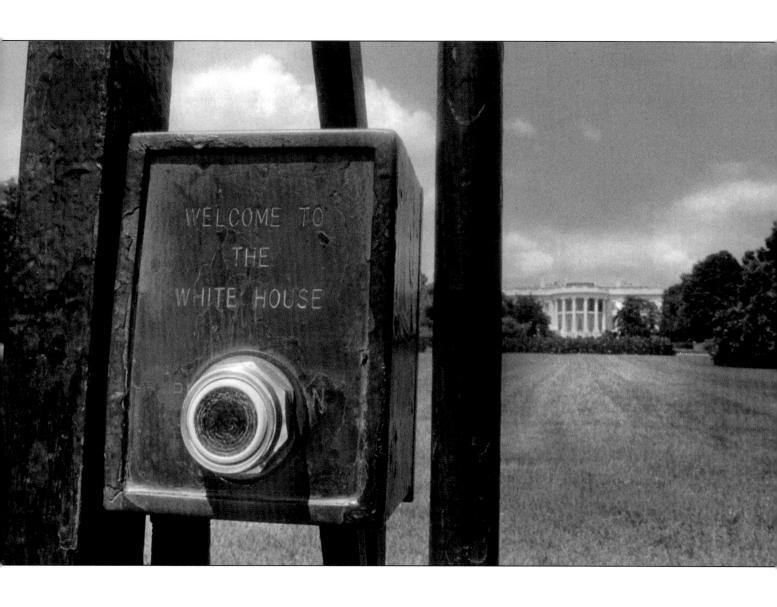

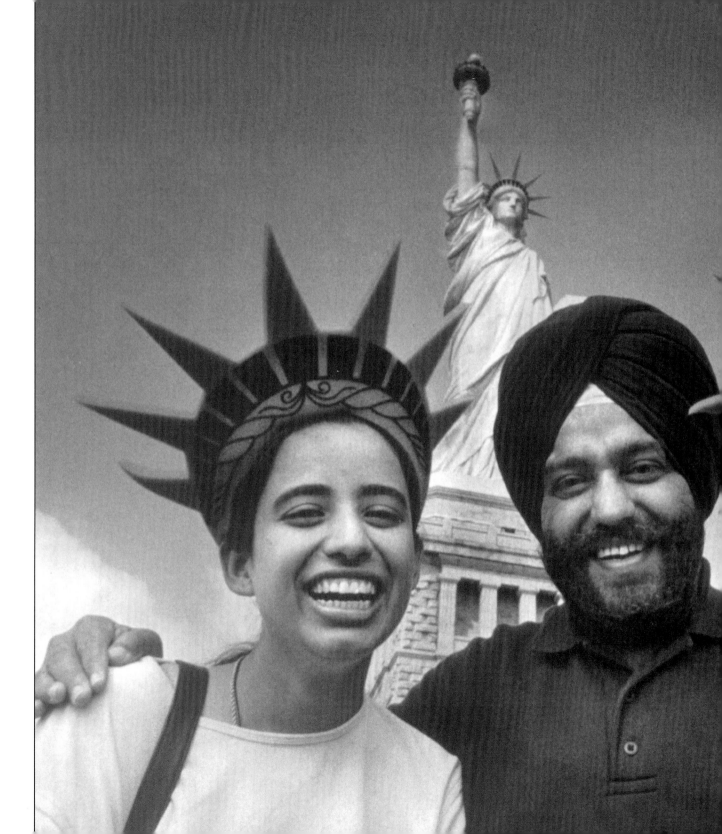

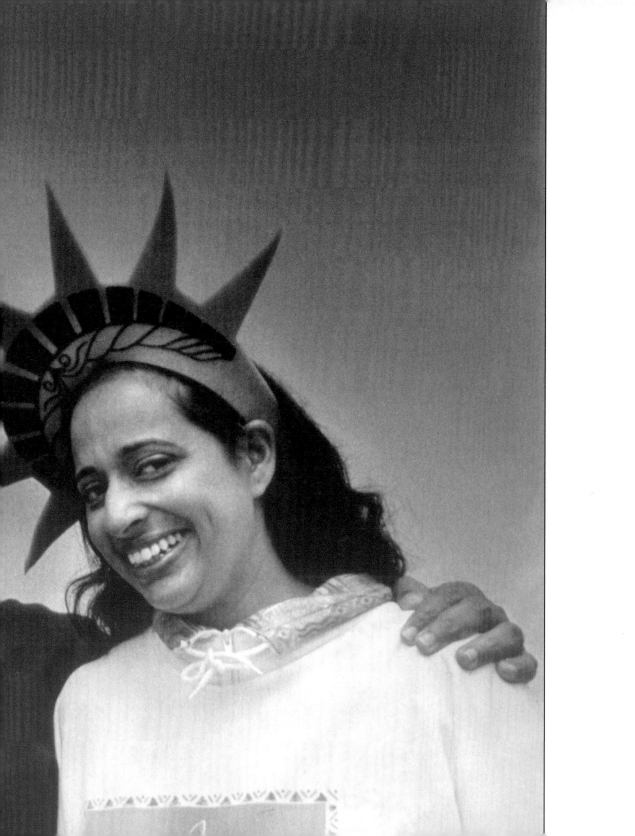

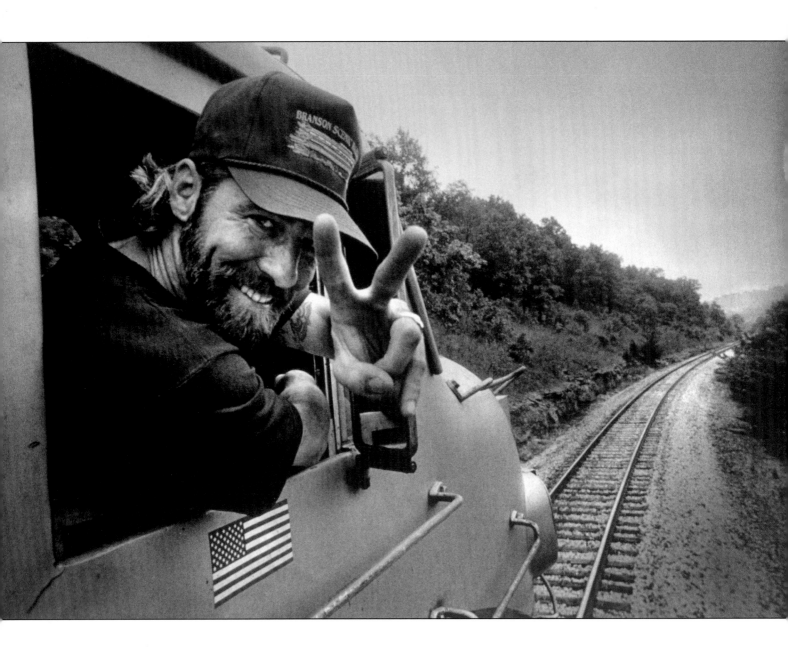

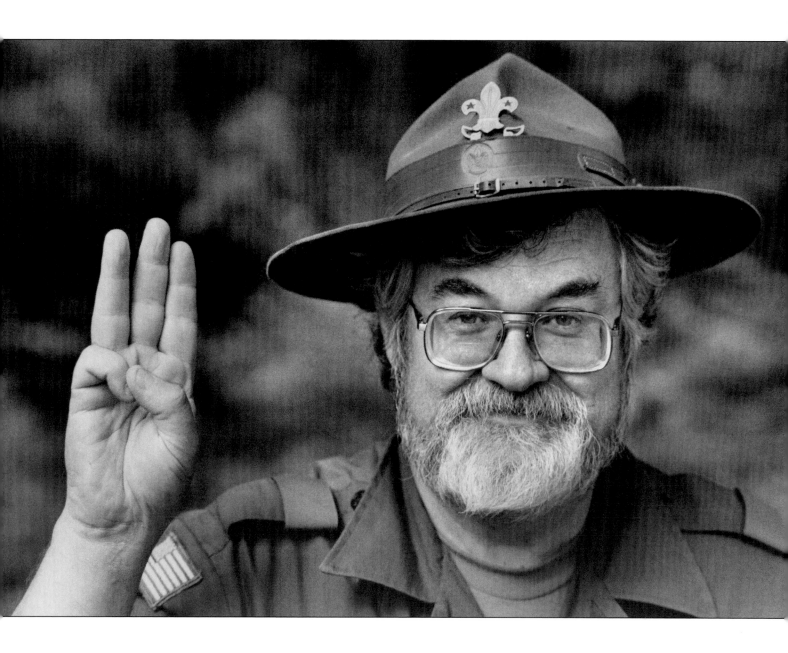

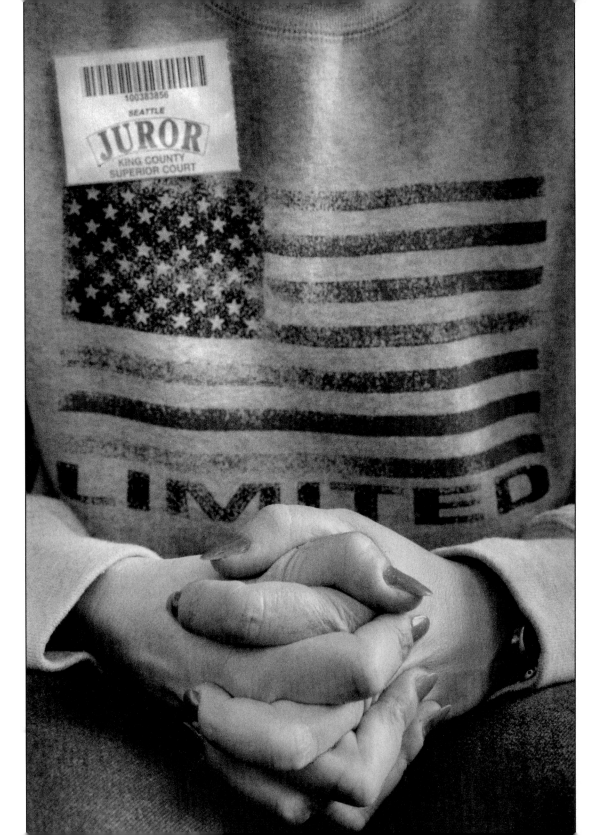

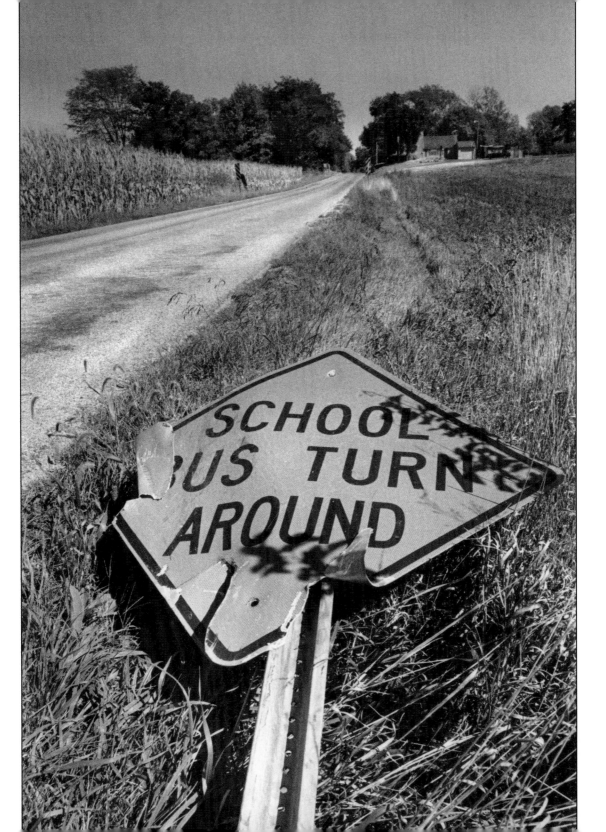

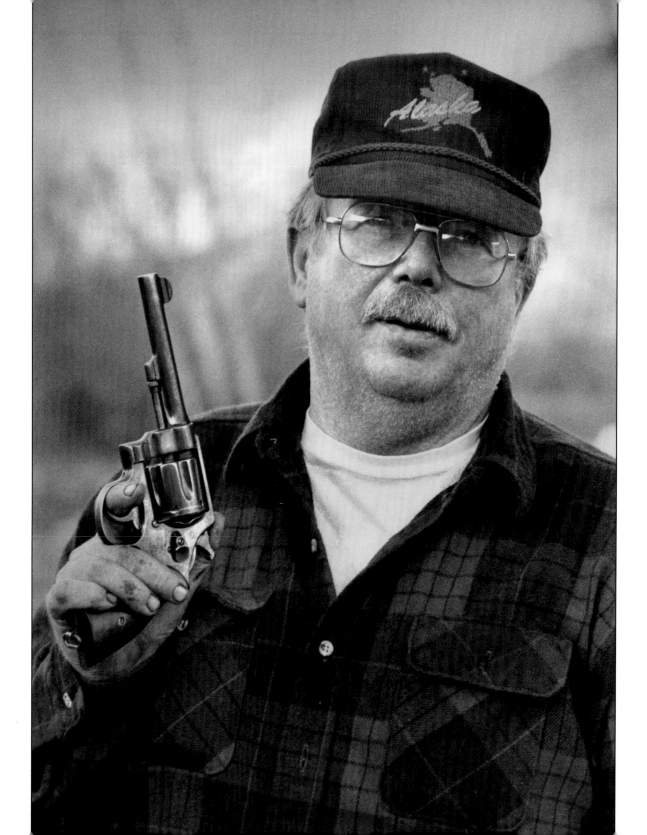

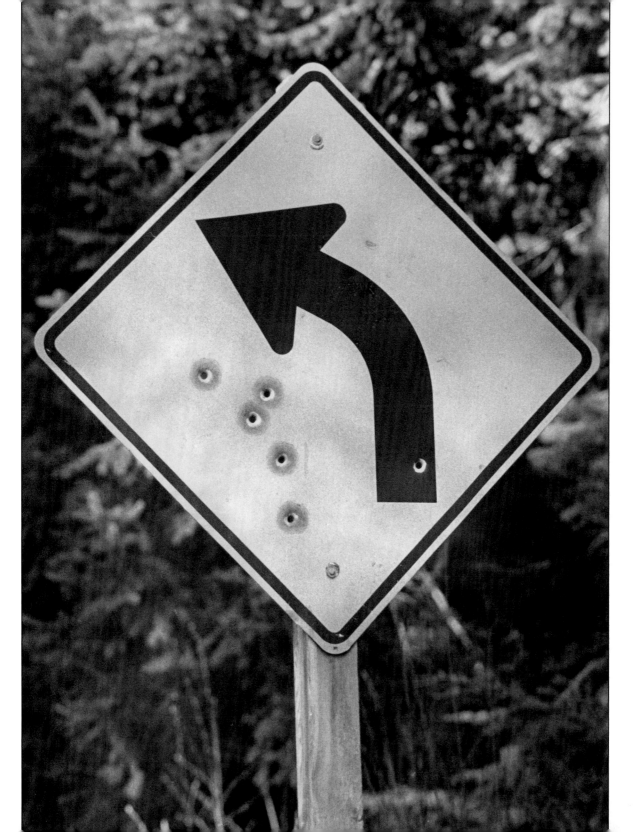

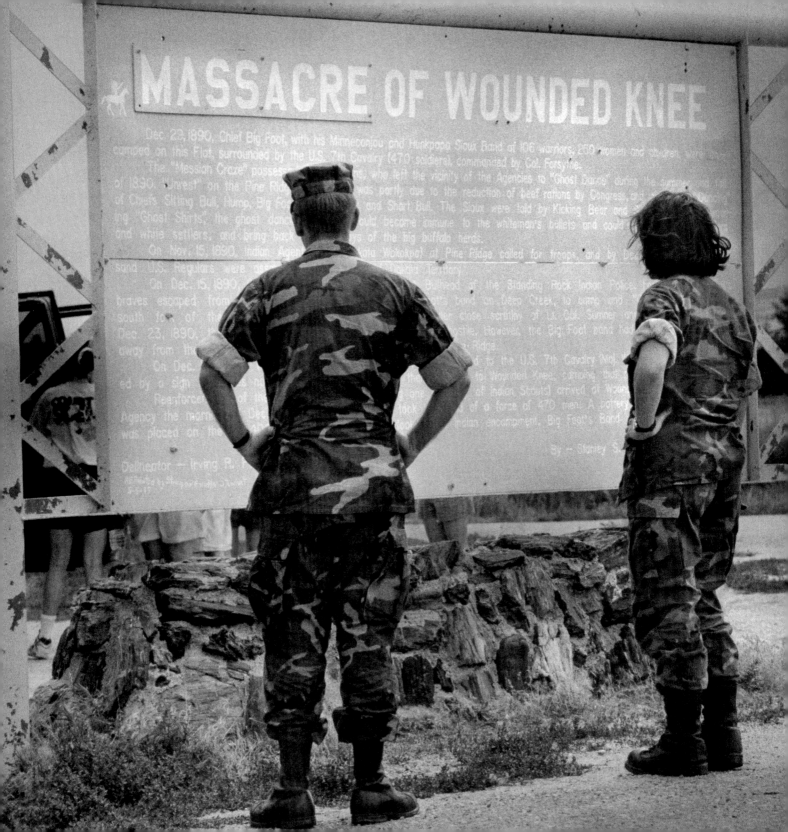

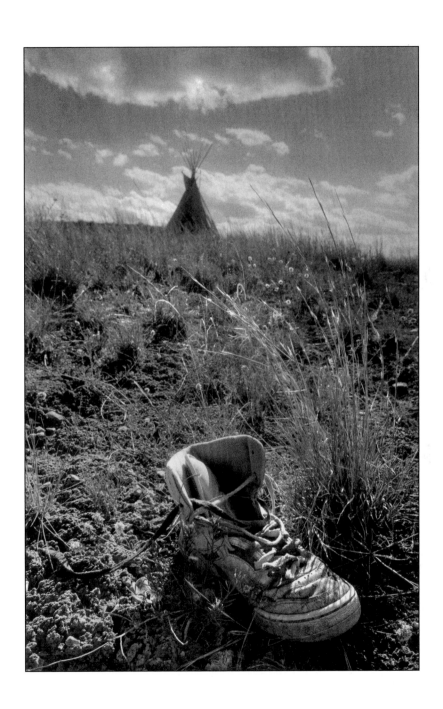

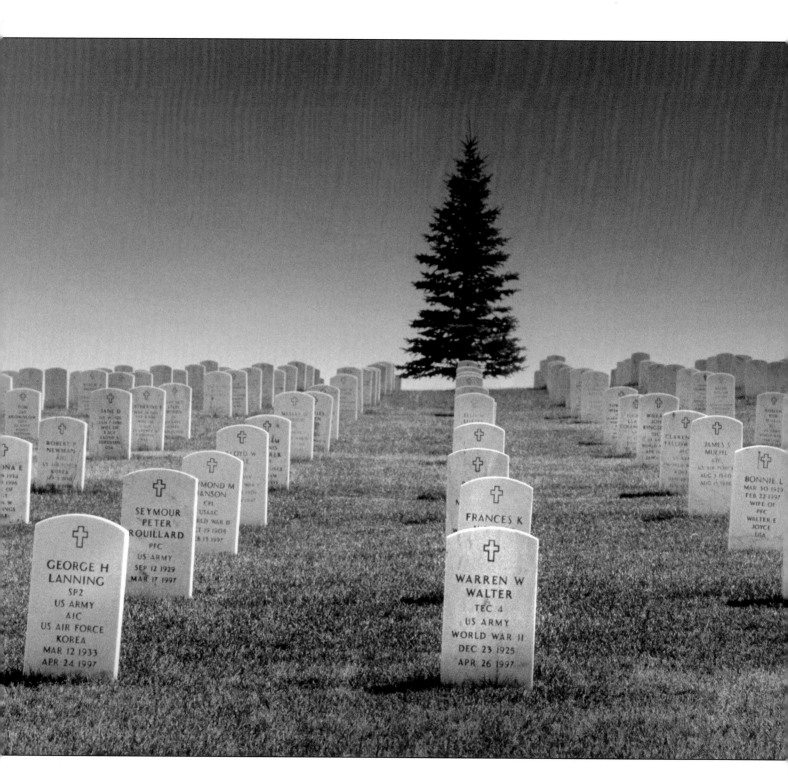

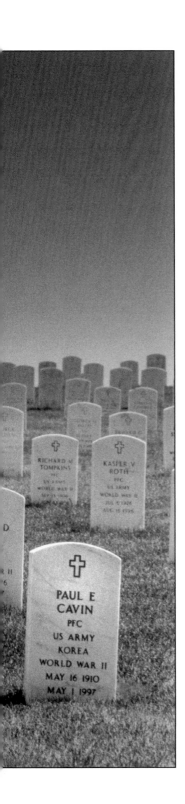

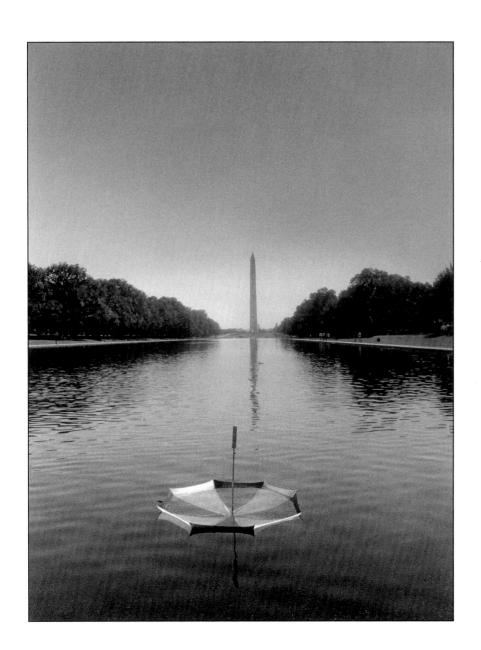

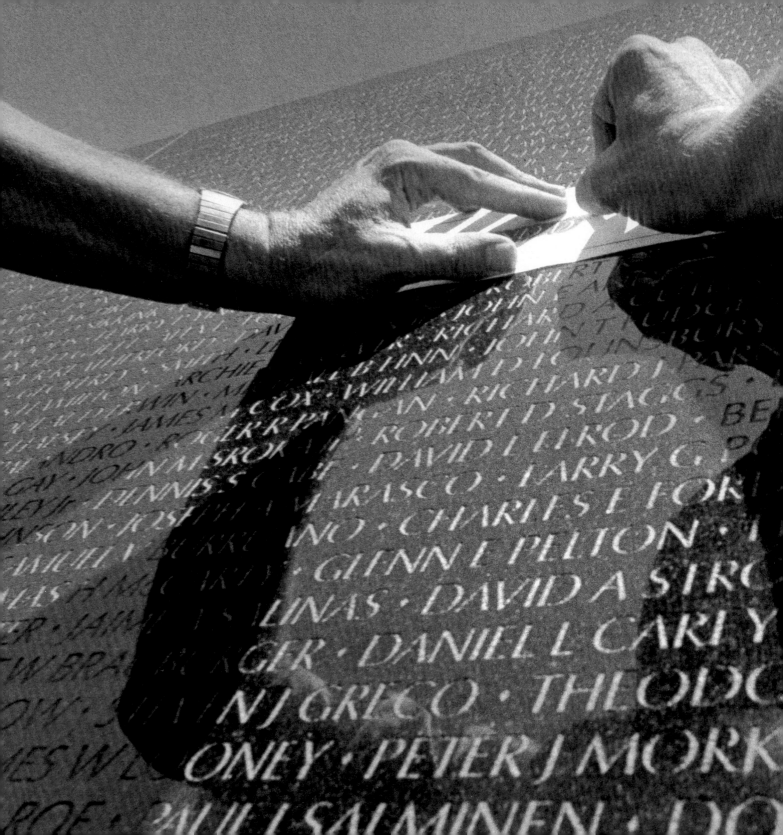

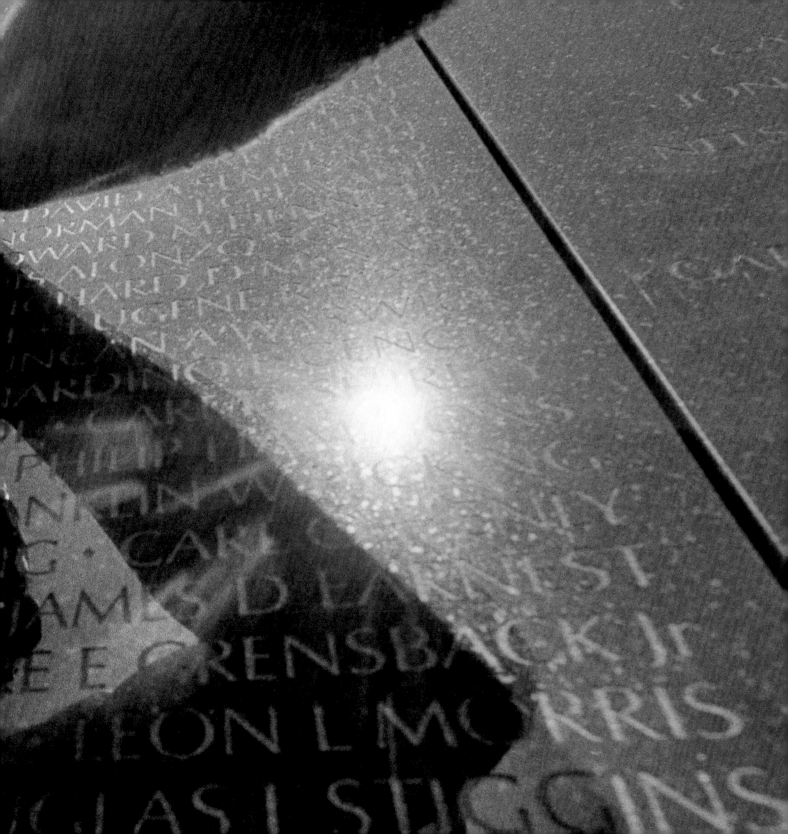

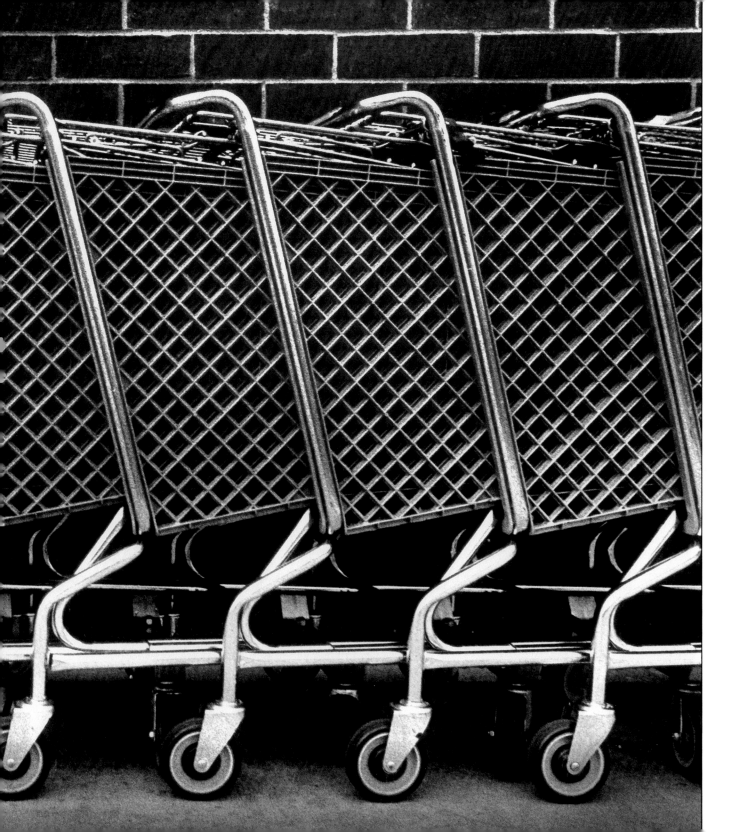

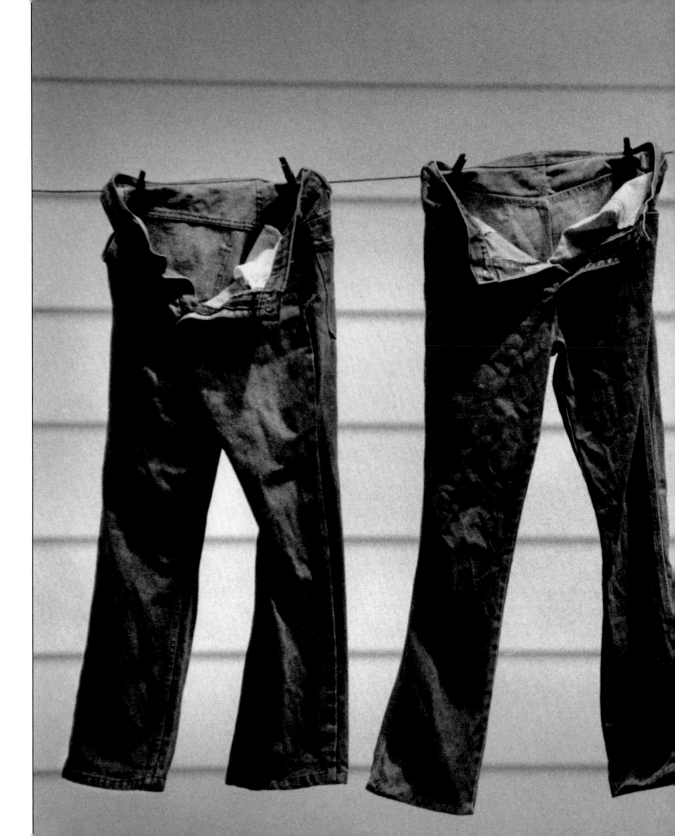

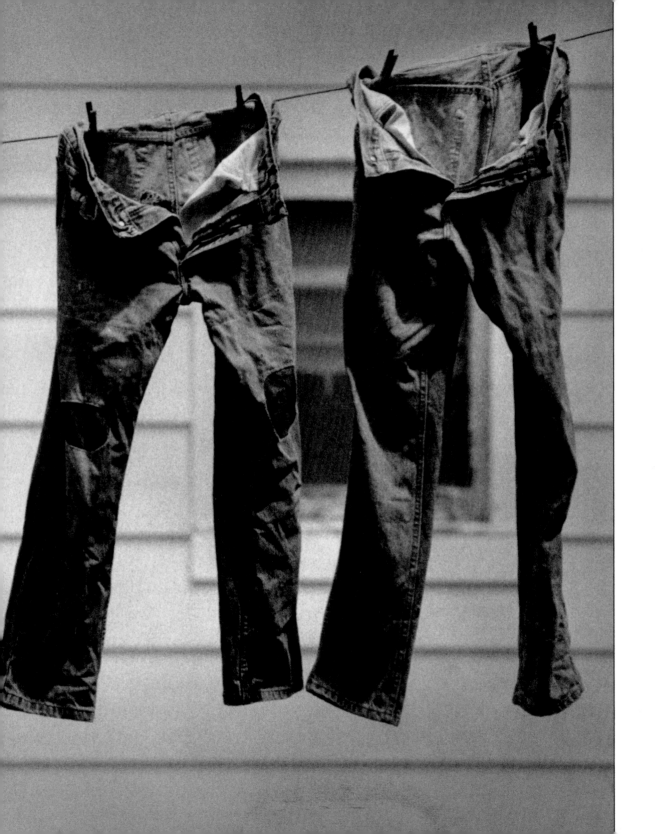

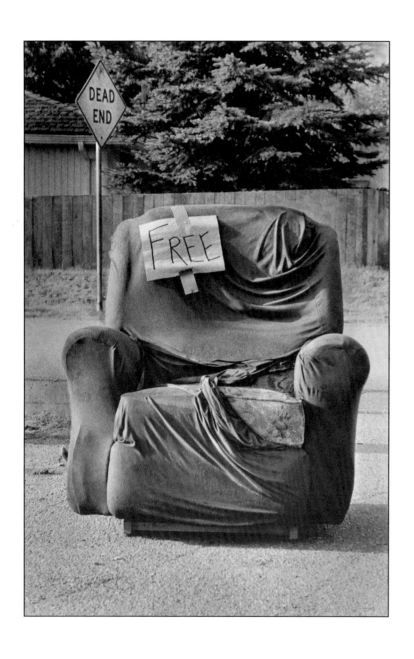

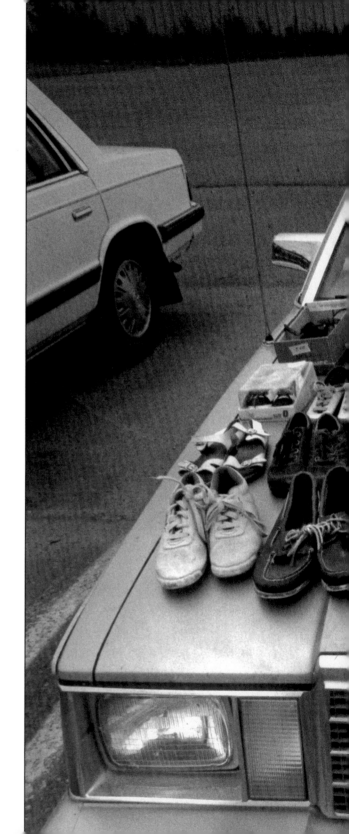

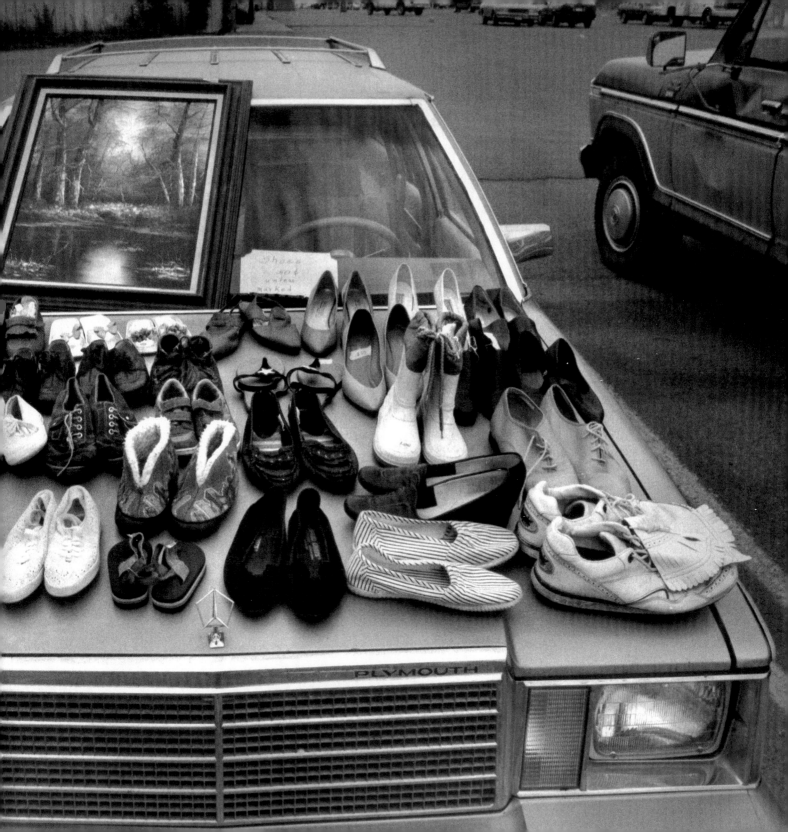

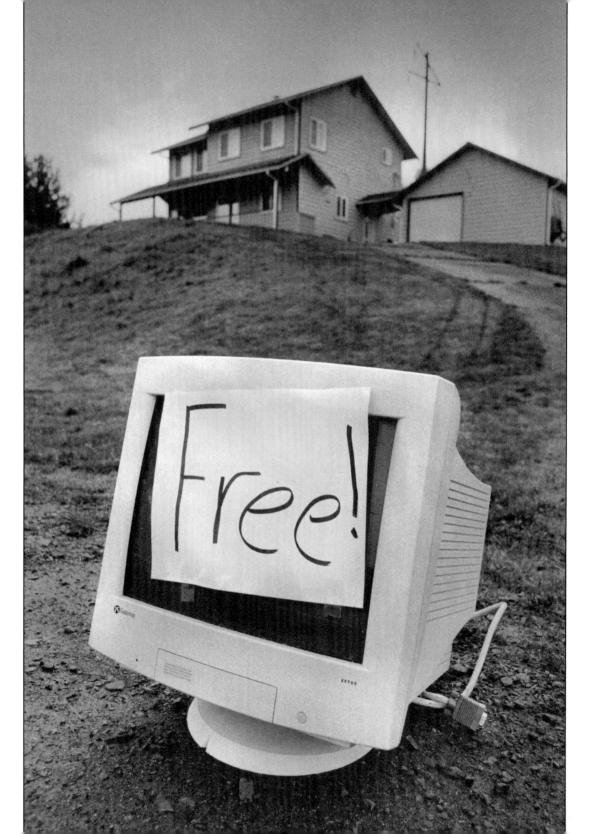

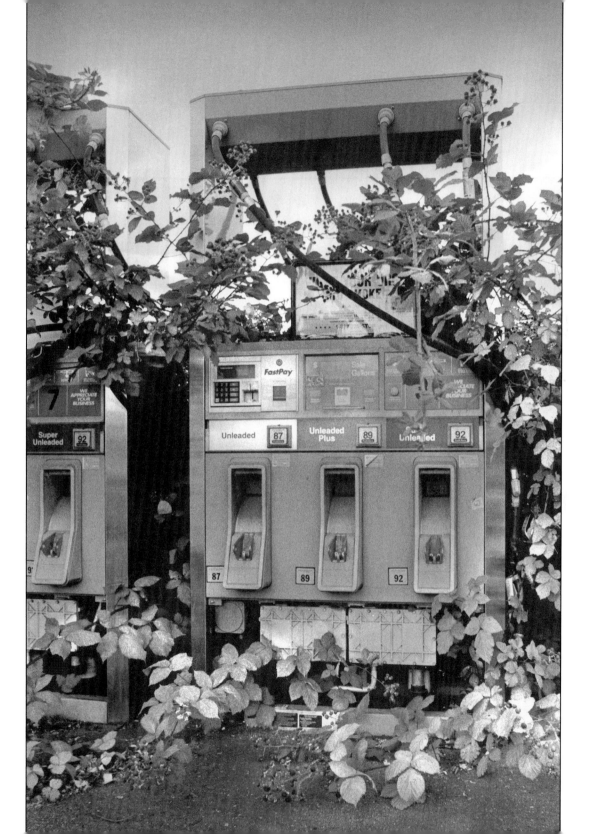

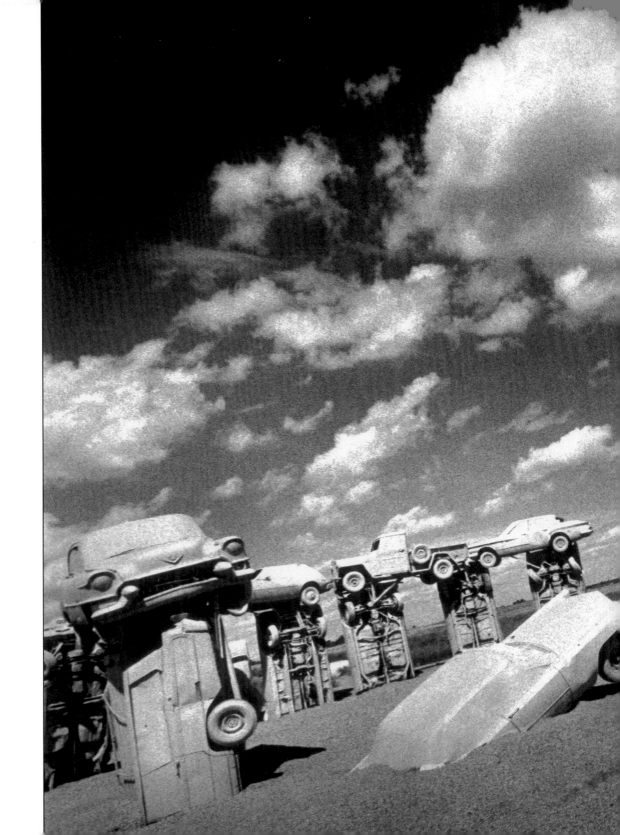

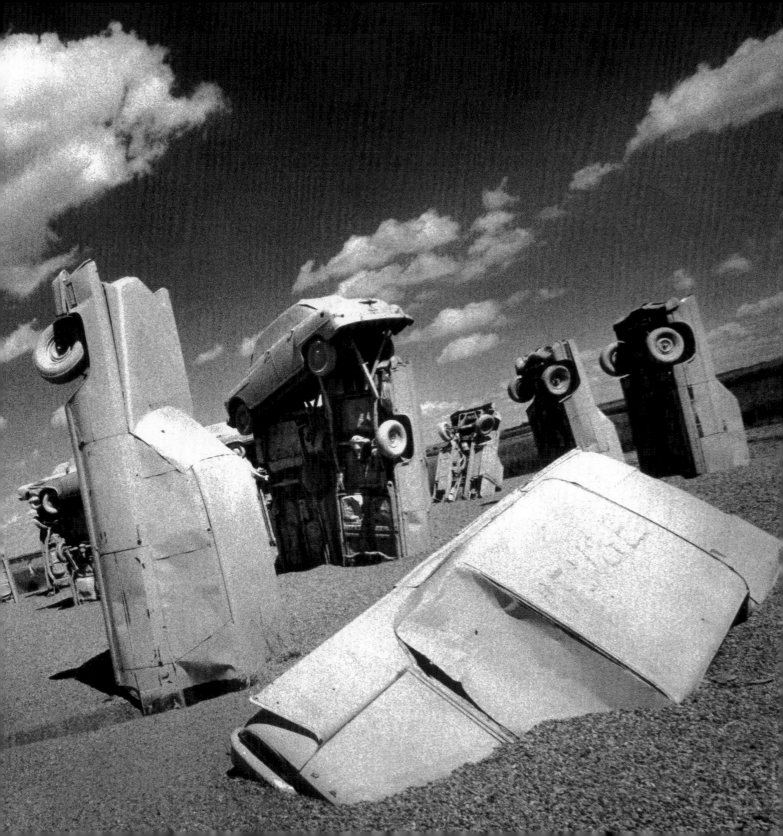

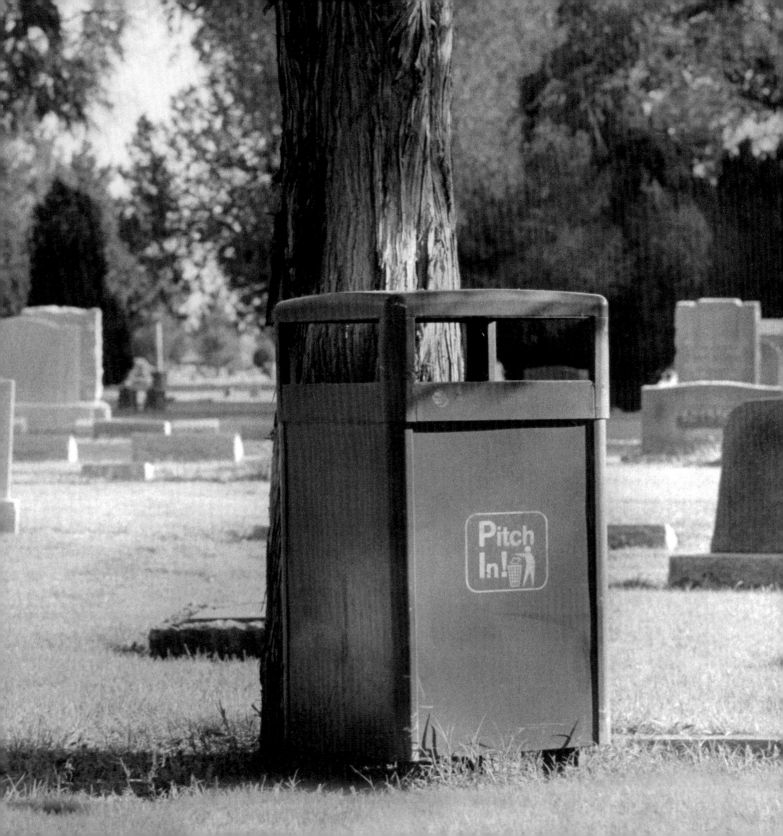

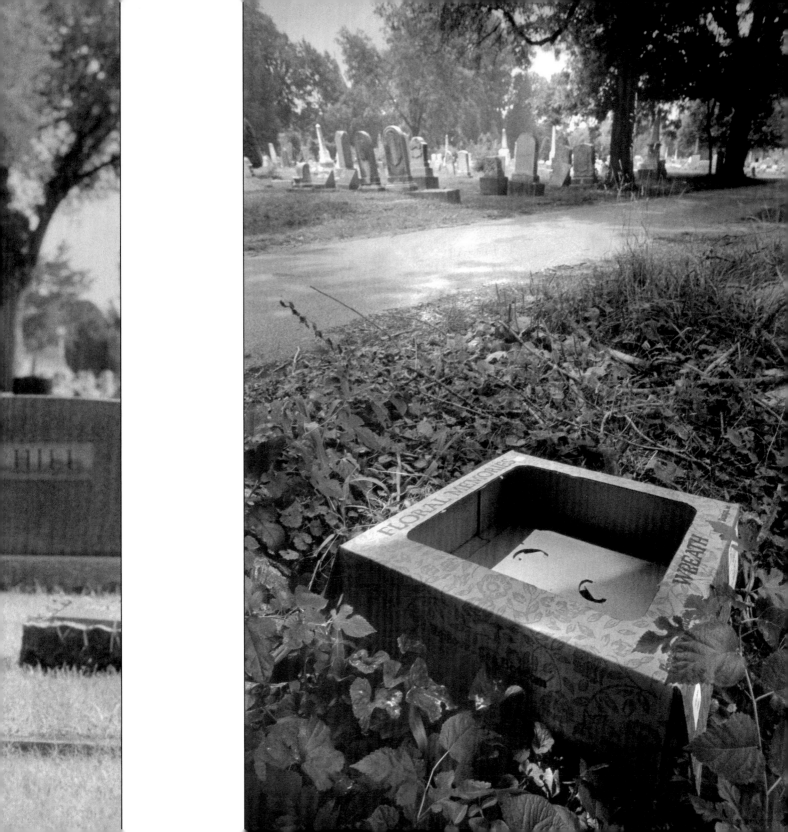

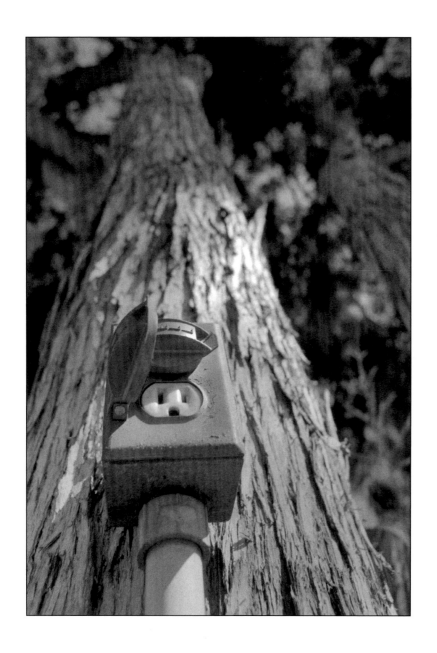
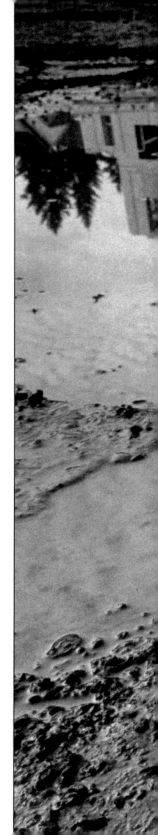

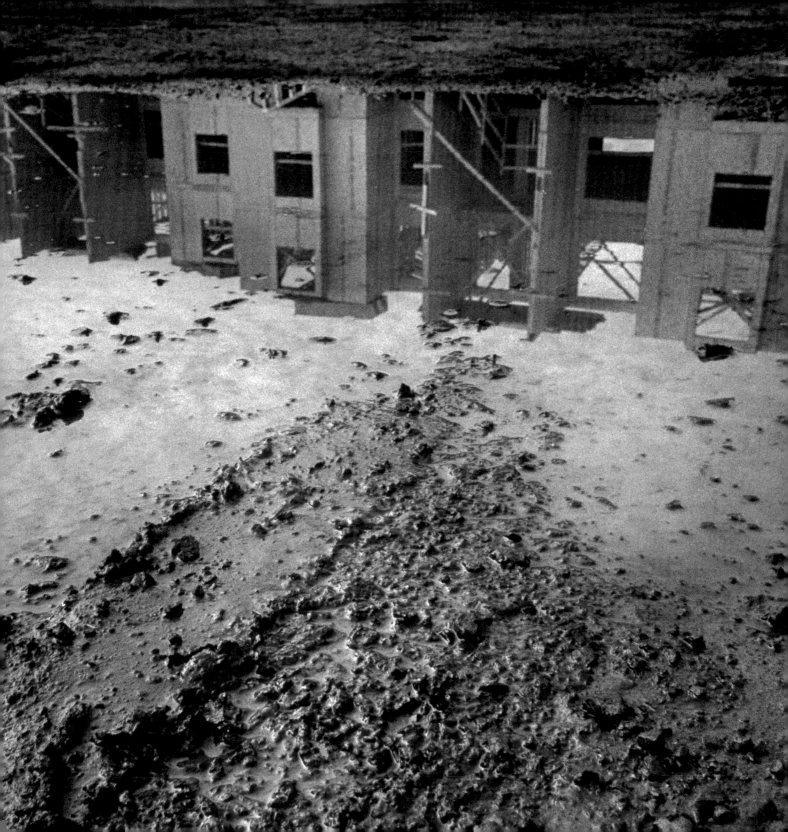

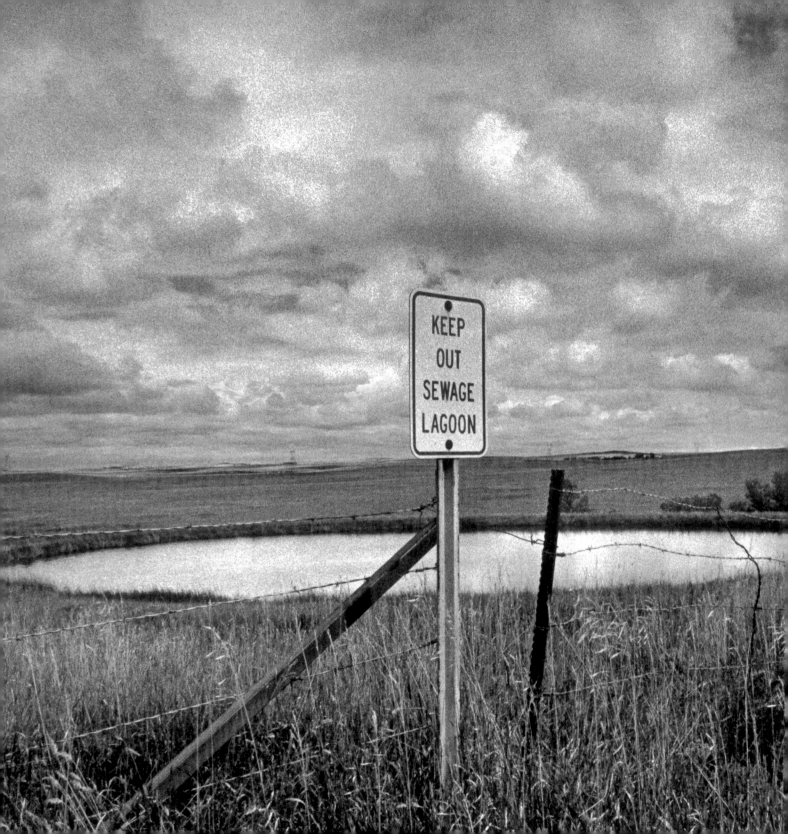

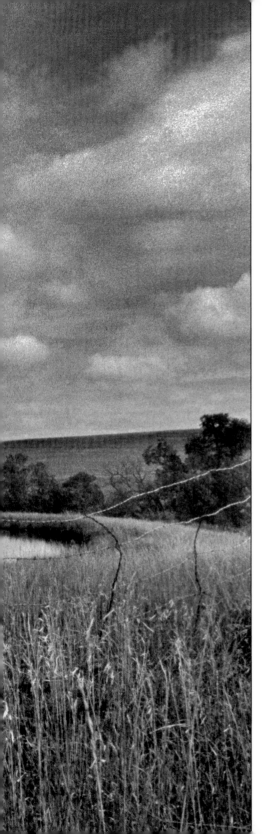

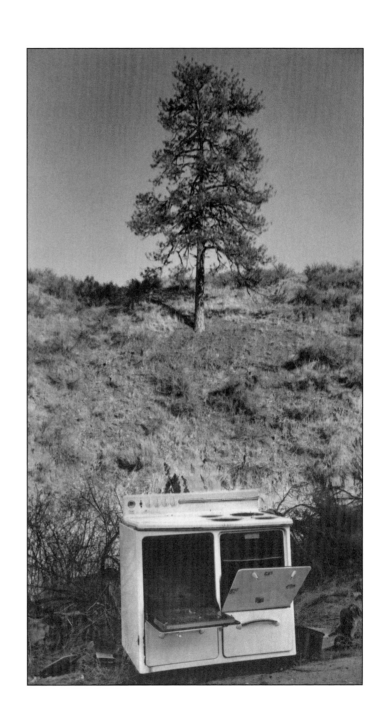

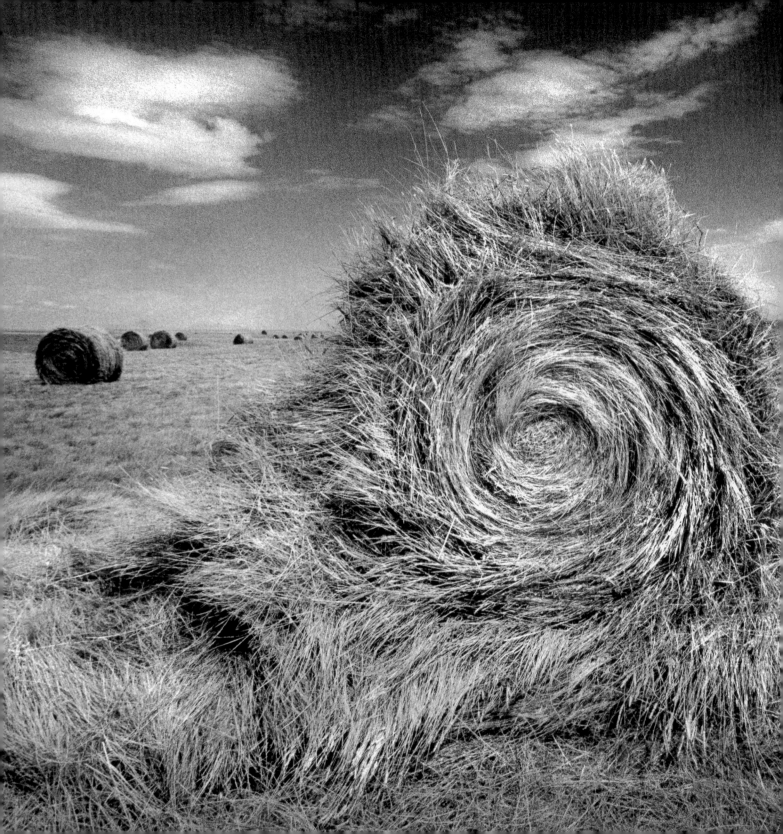

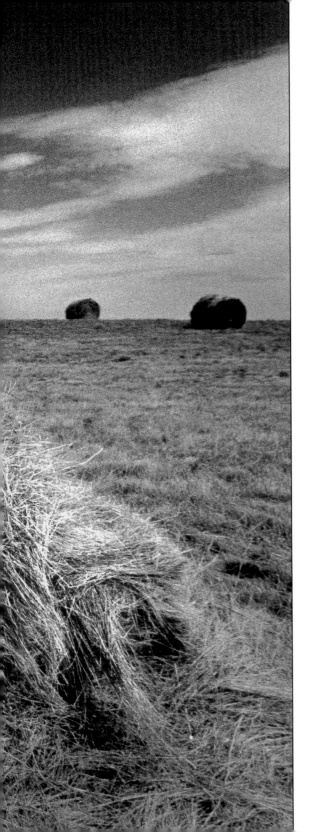
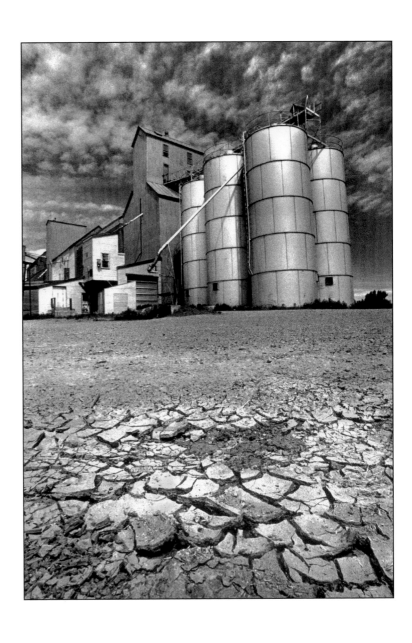

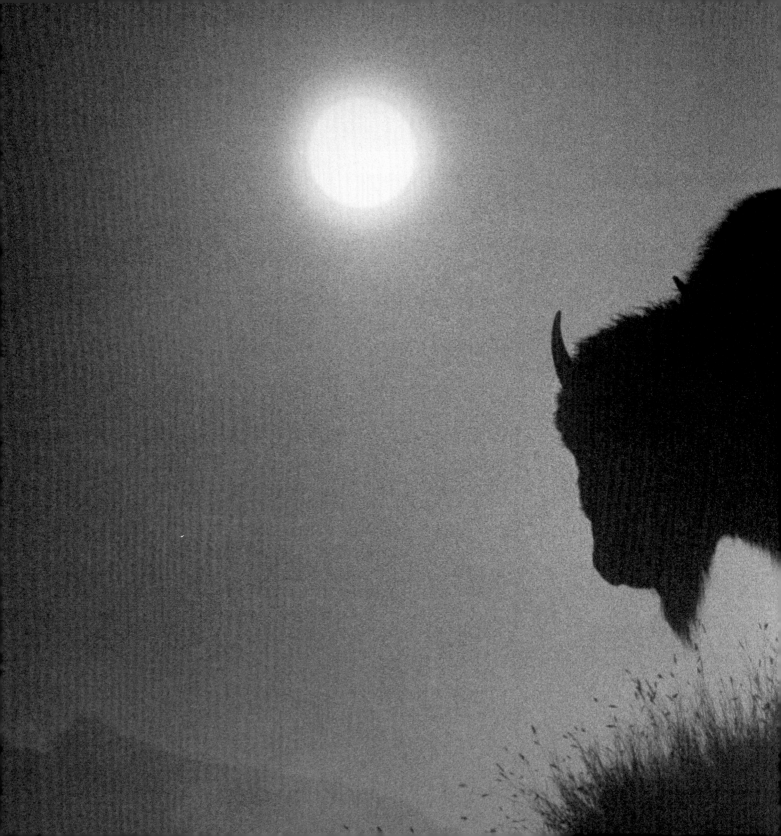

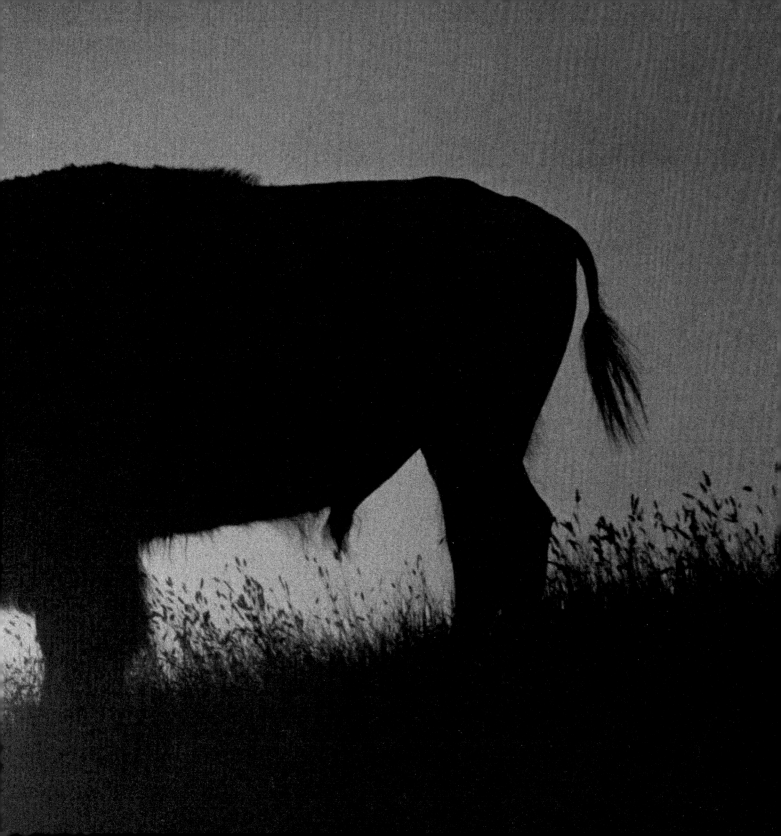

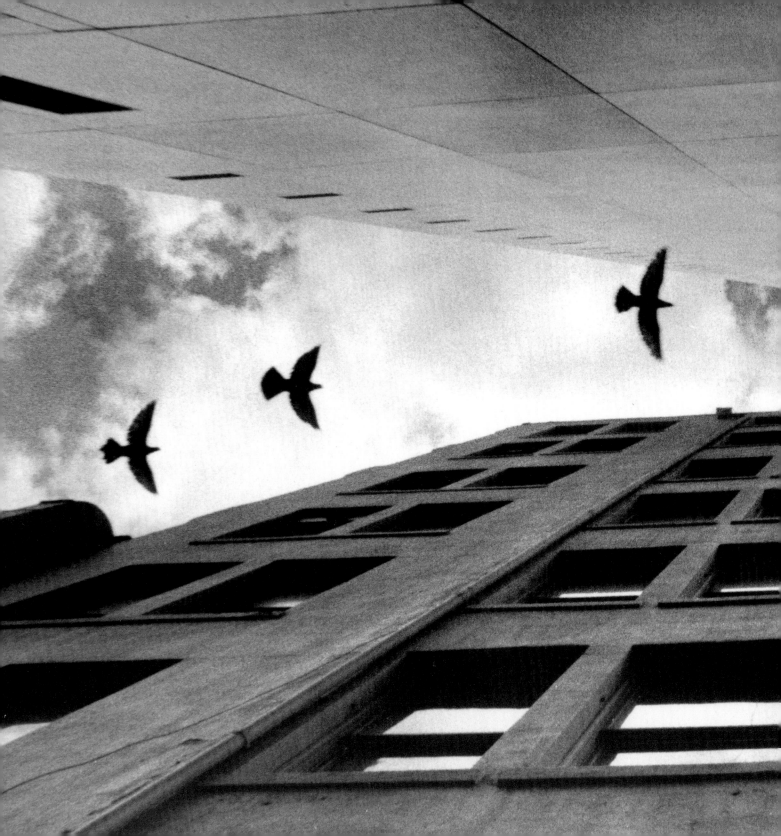

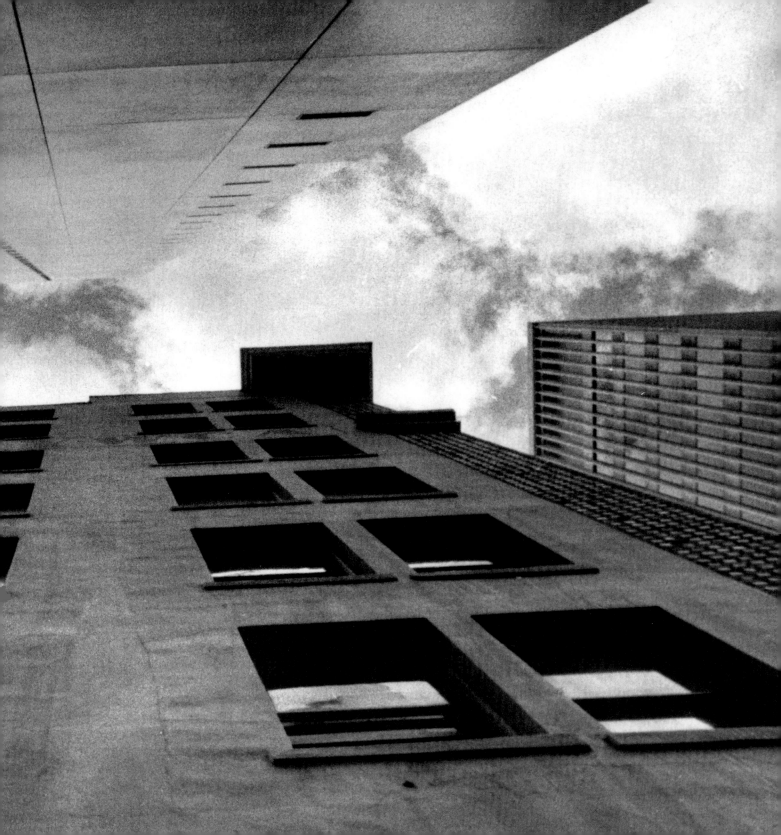

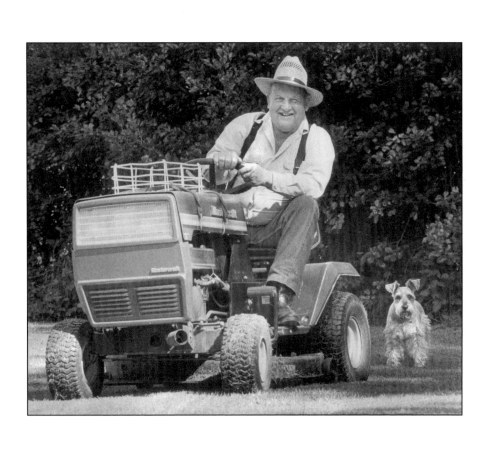

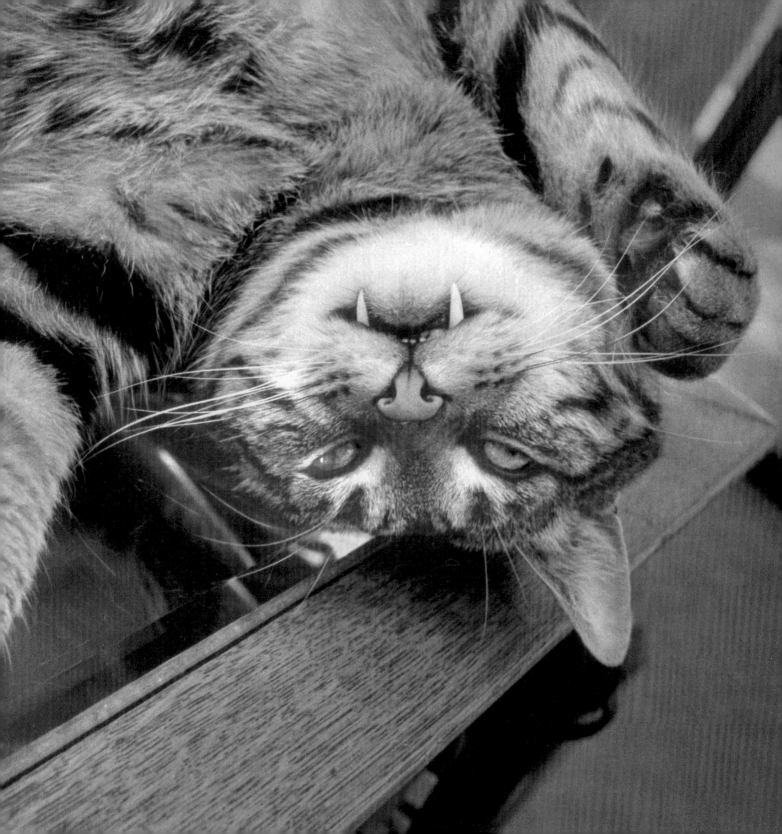

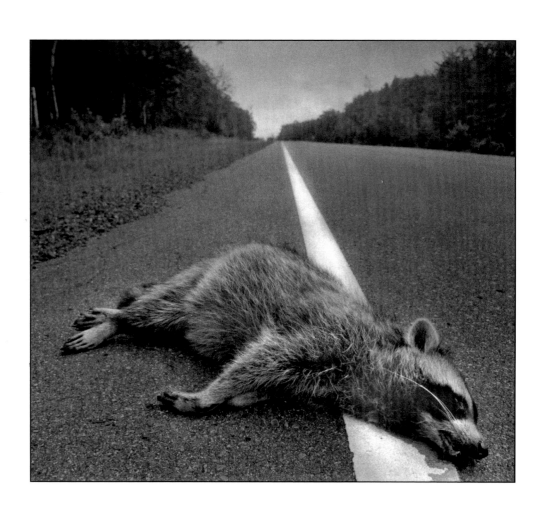
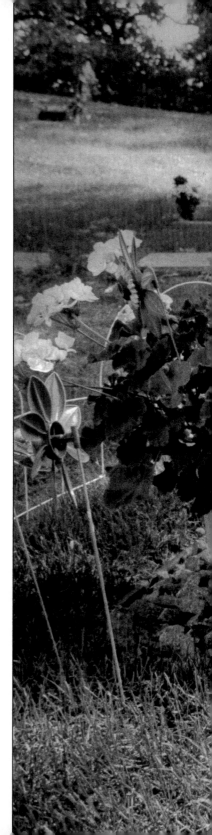

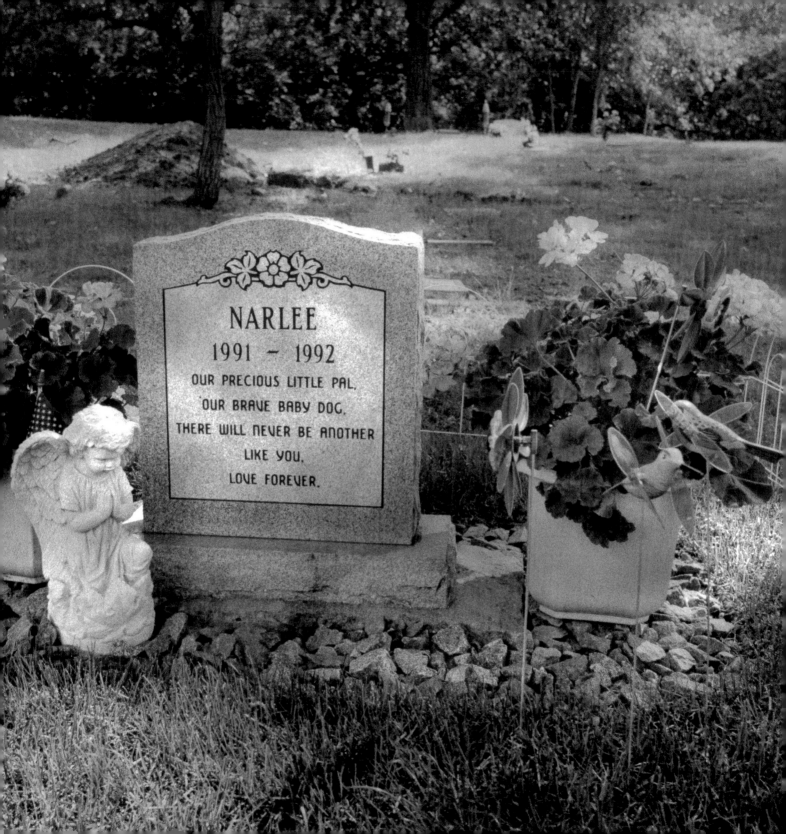

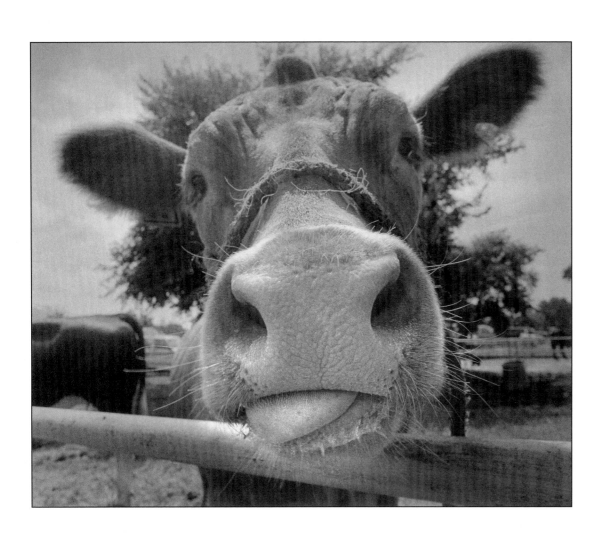

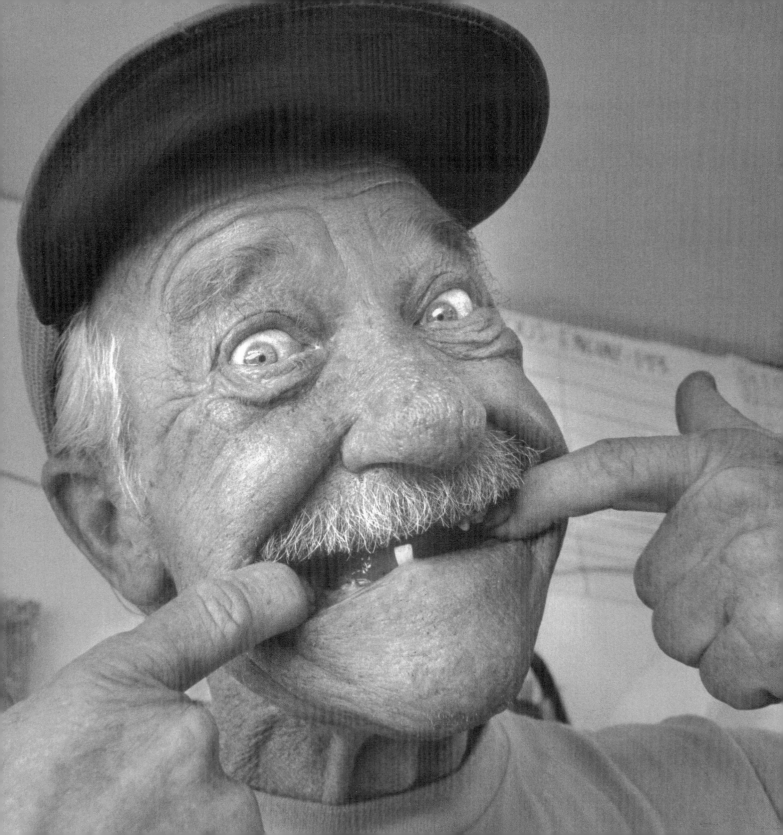

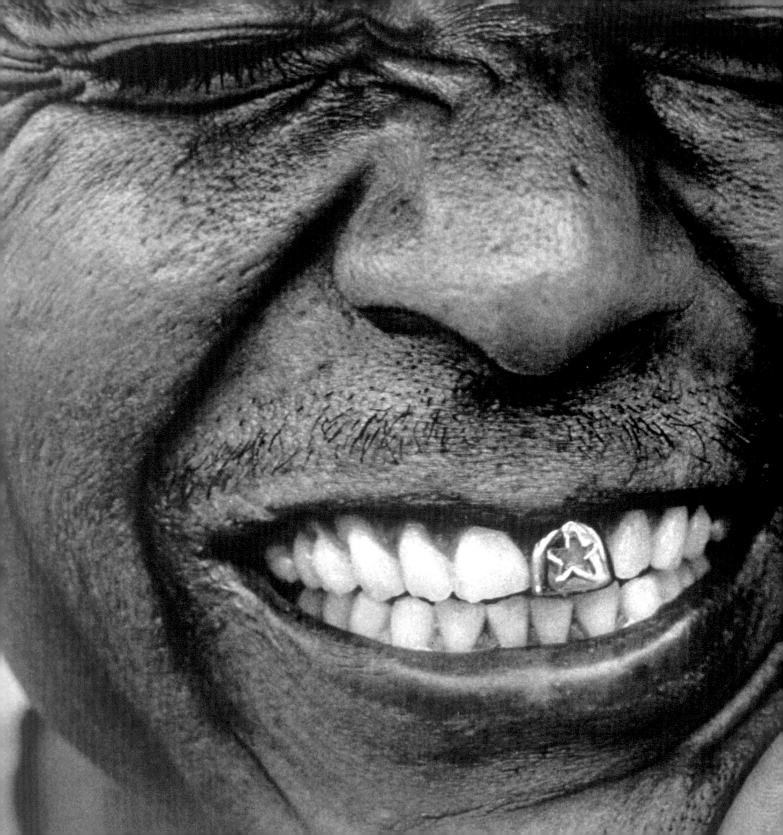

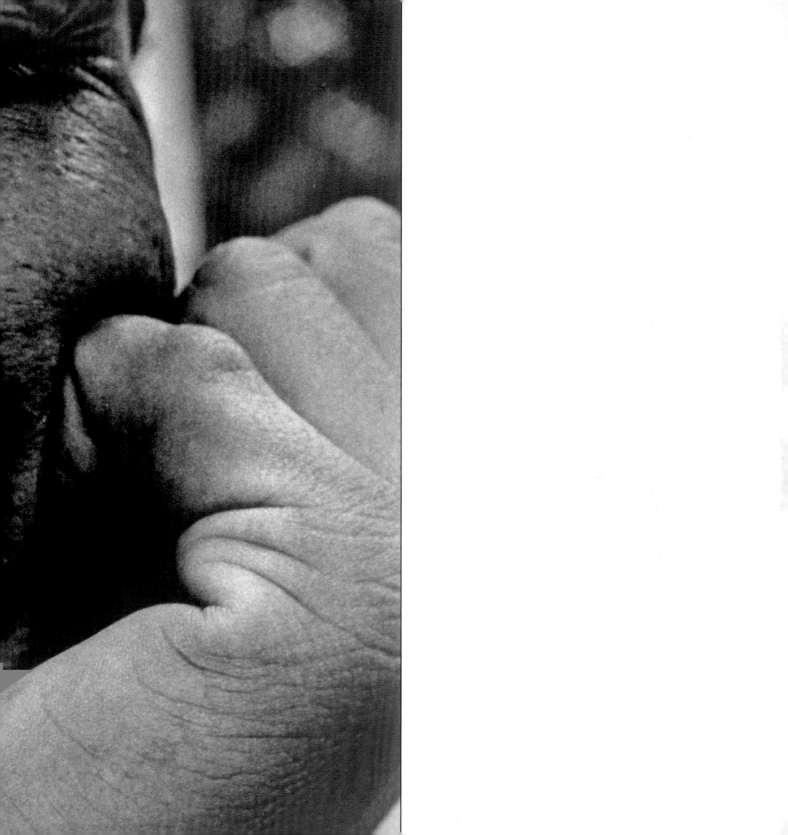

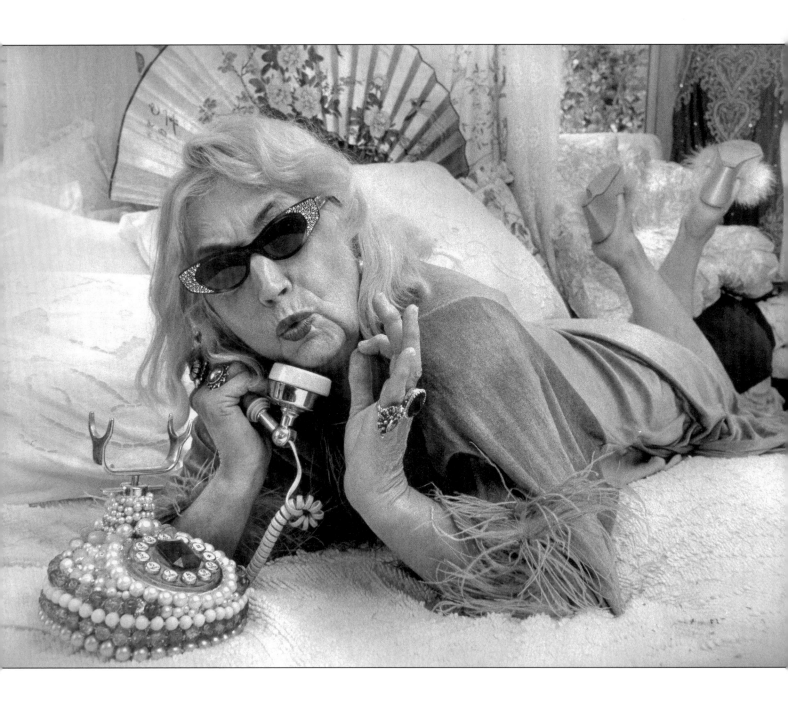

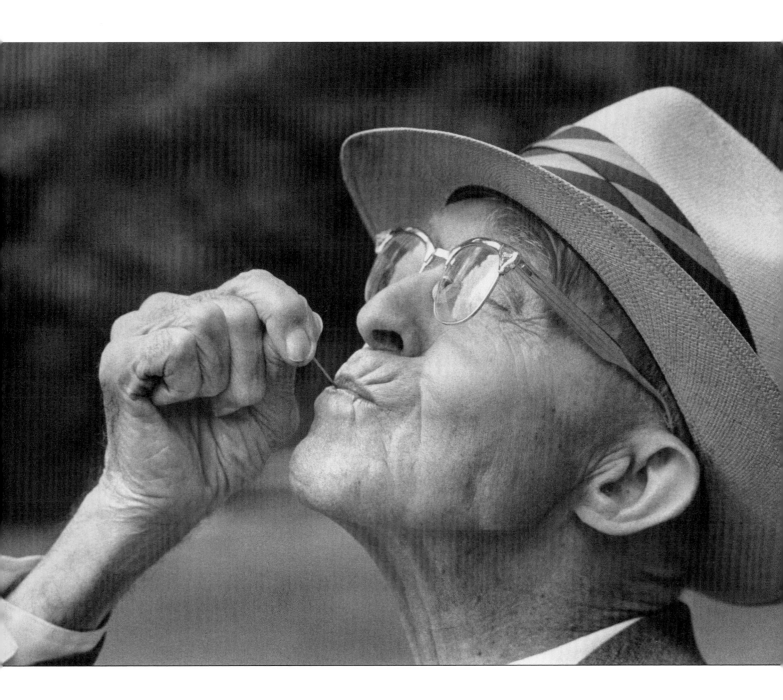

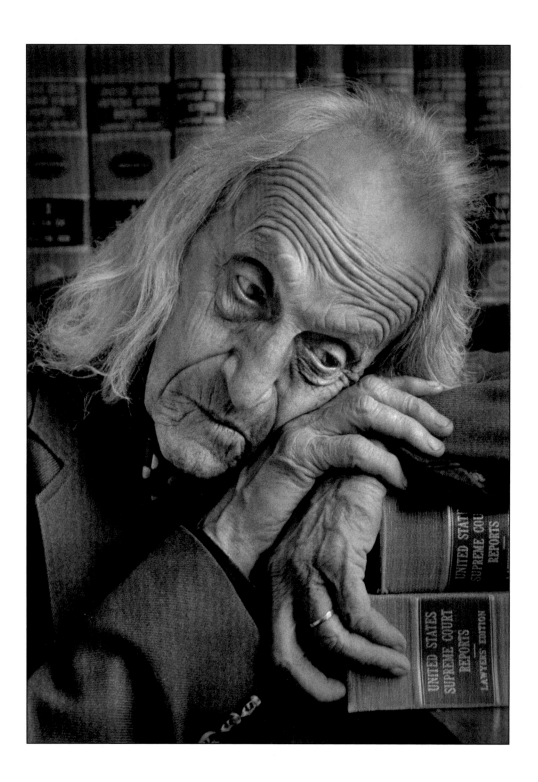

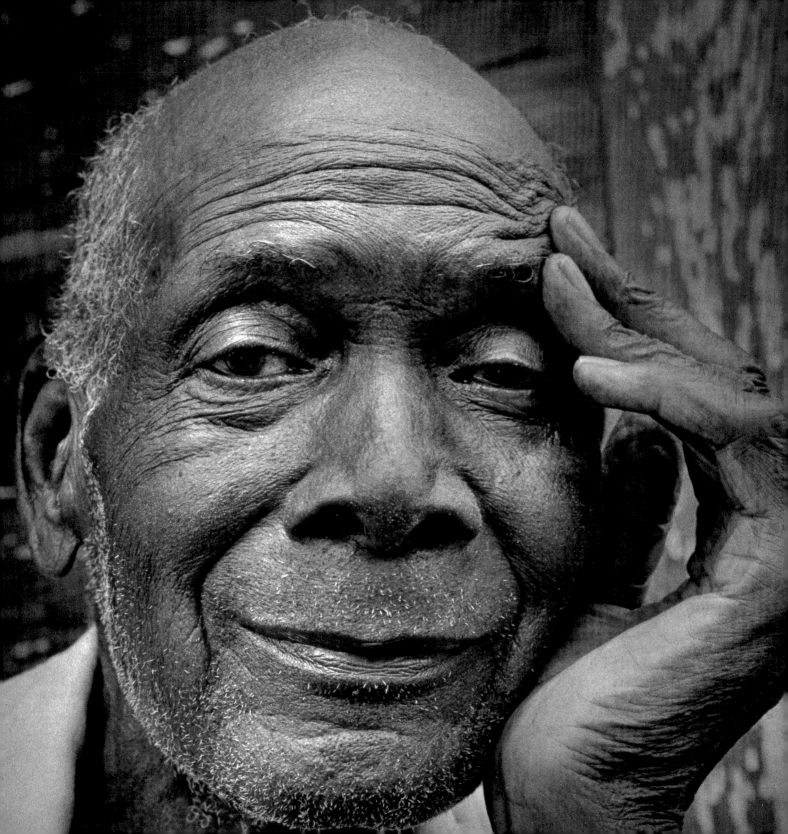

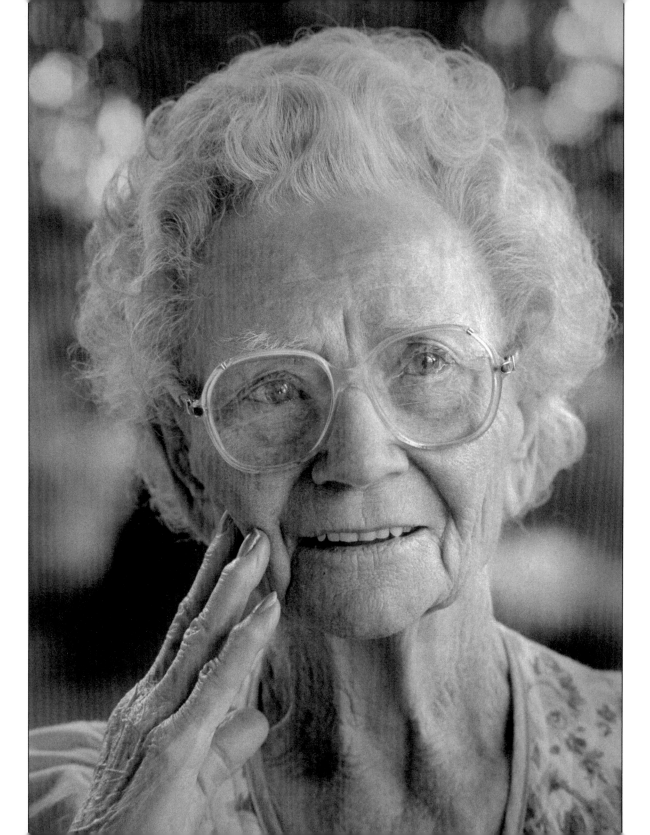

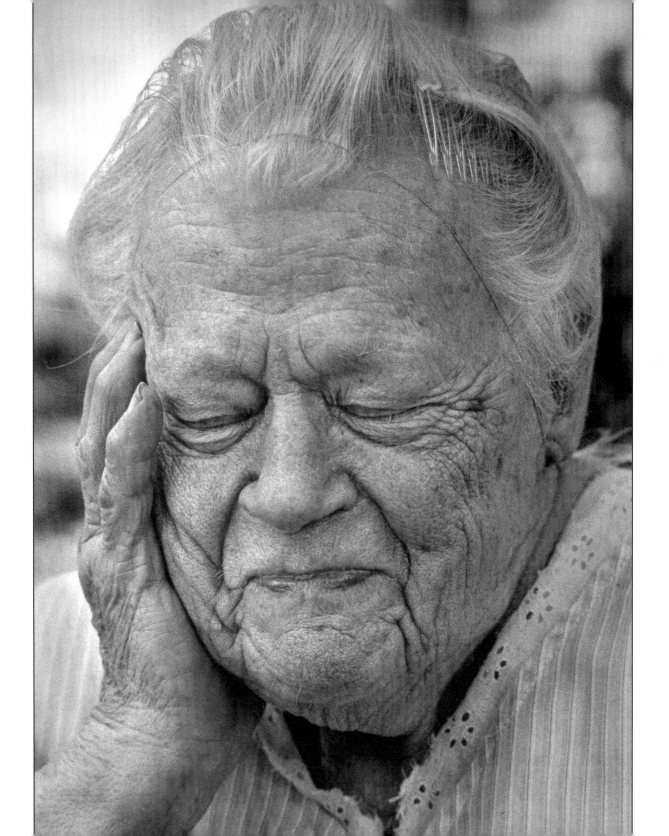

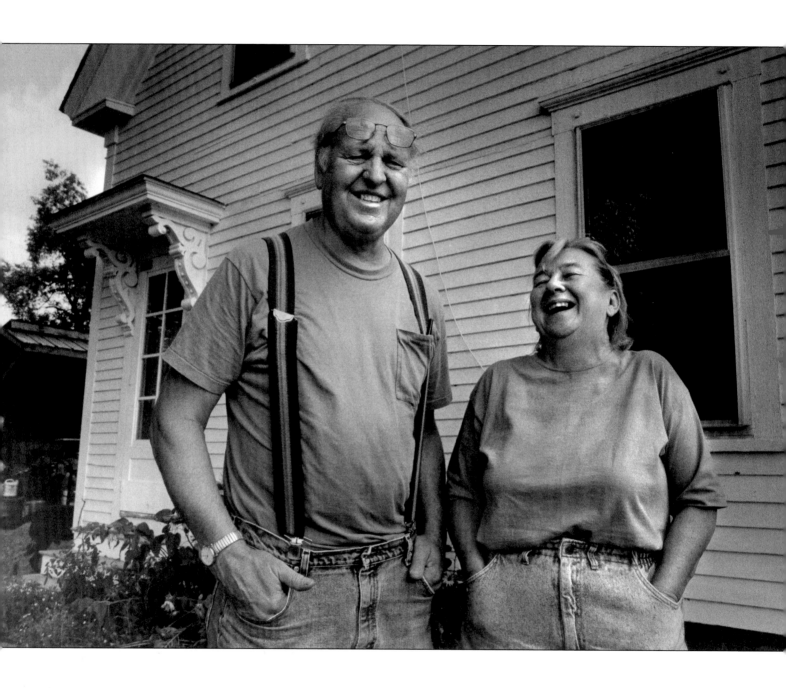

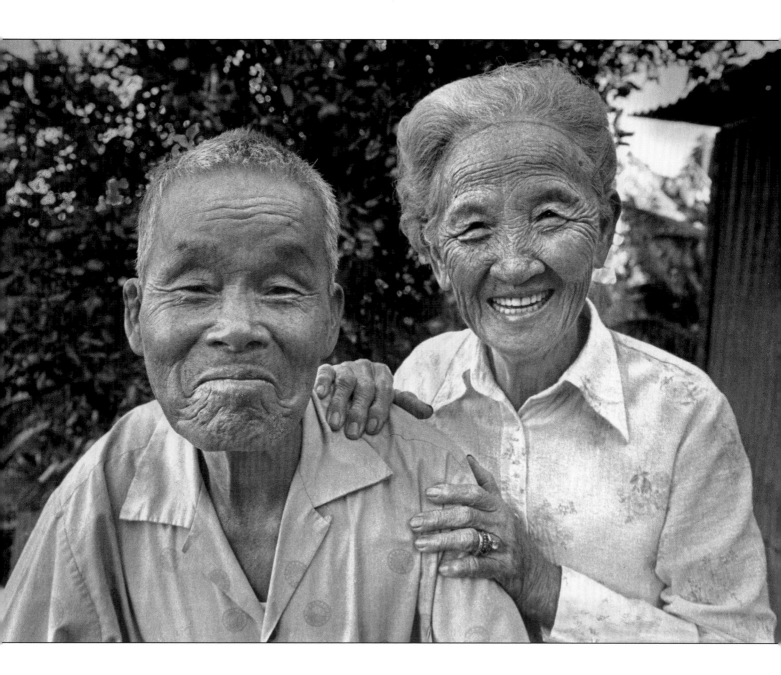

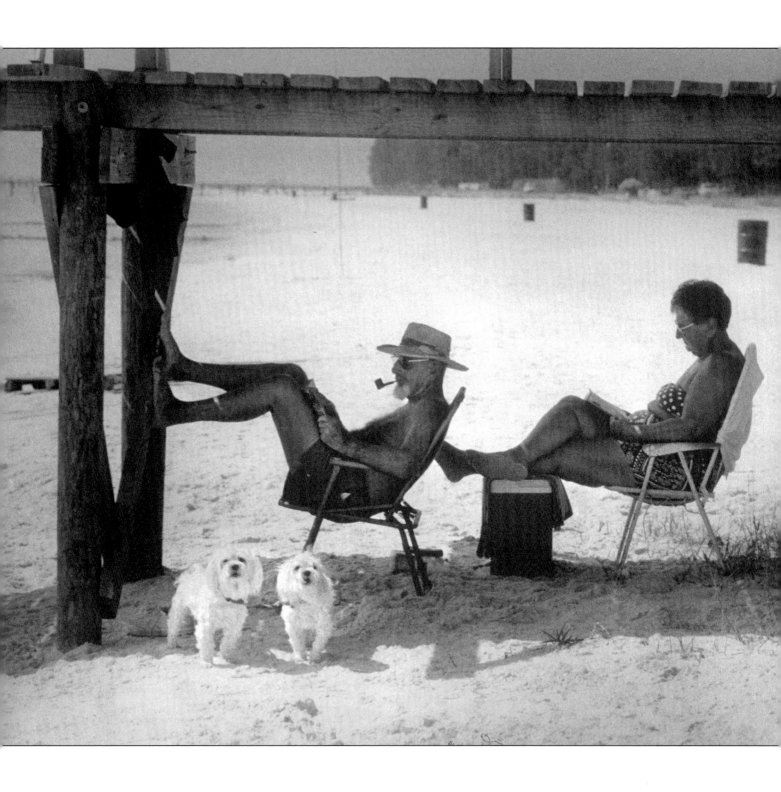

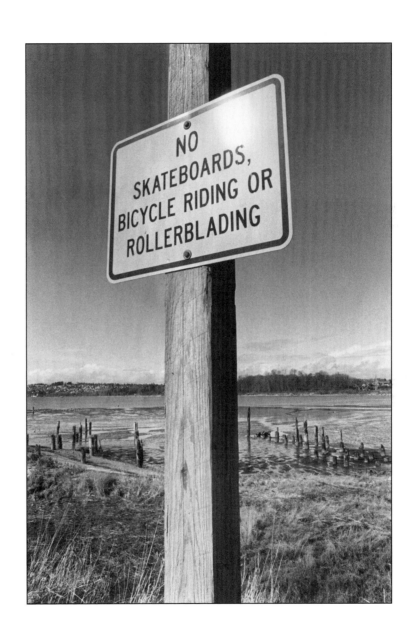

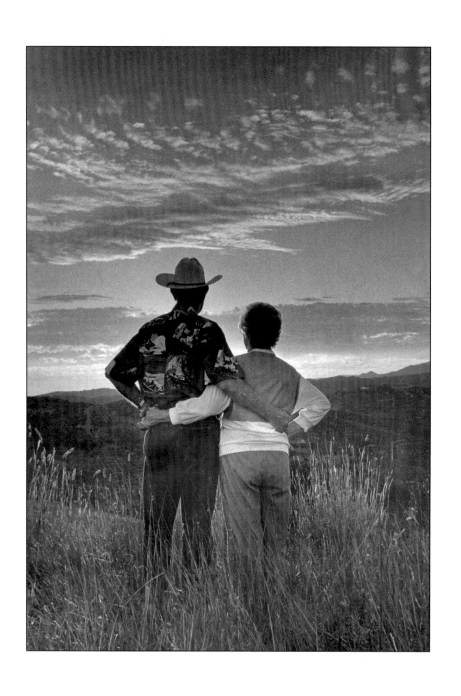

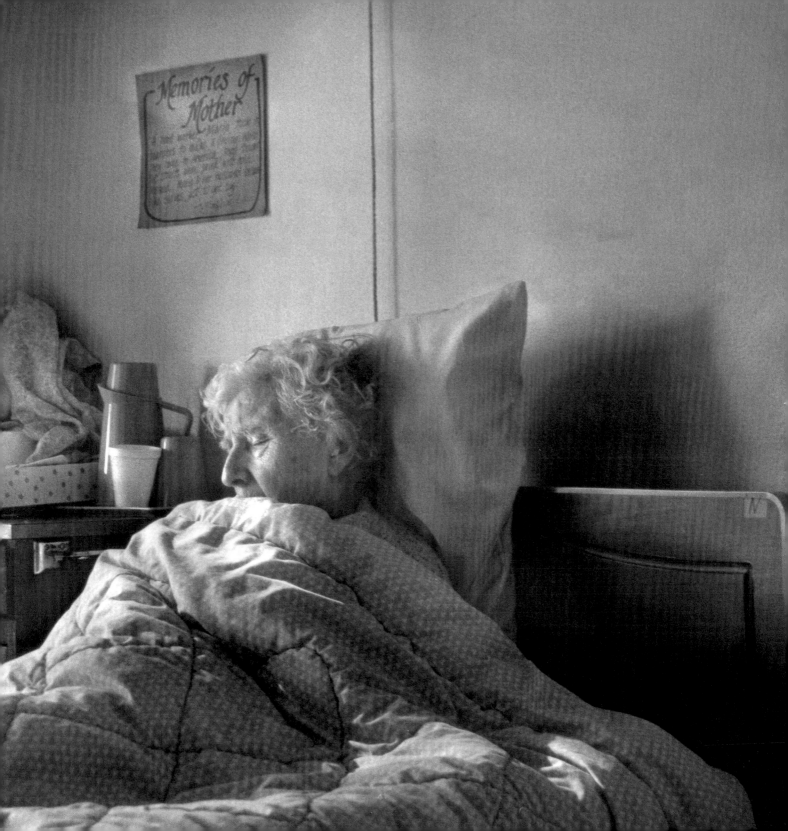

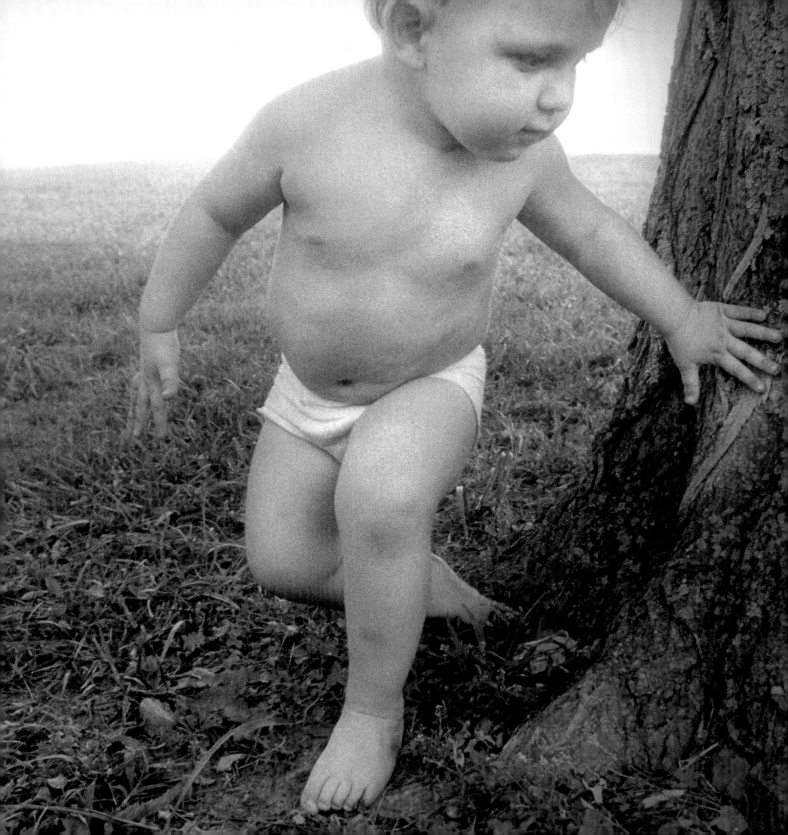

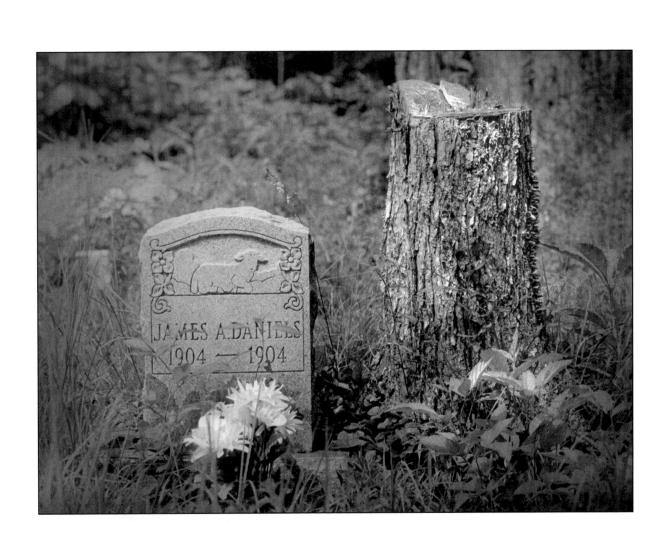

At the end of our life
all we take with us are
pictures of the reality
we created in our soul.

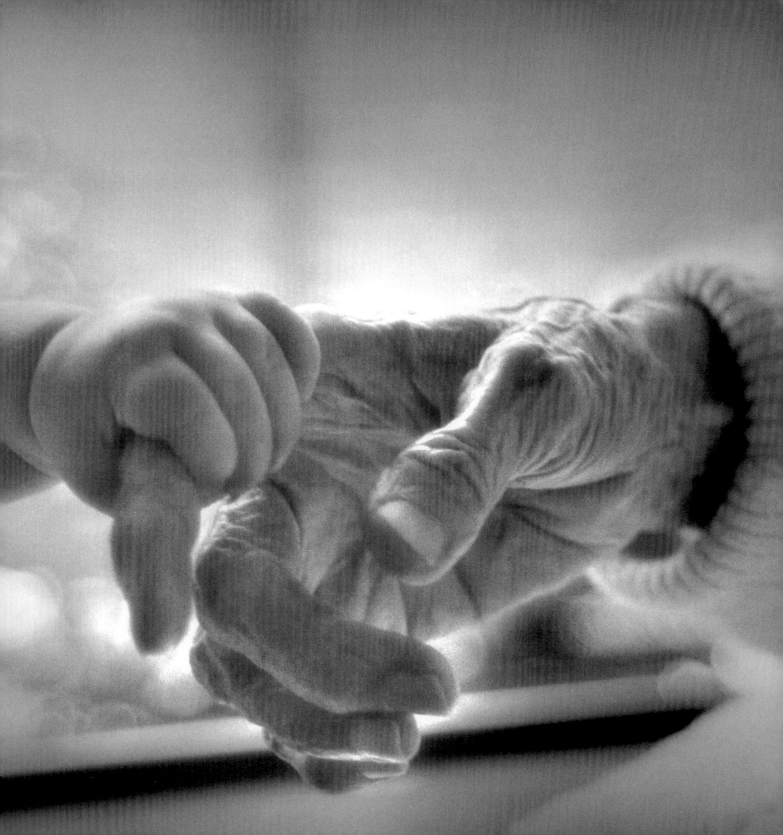

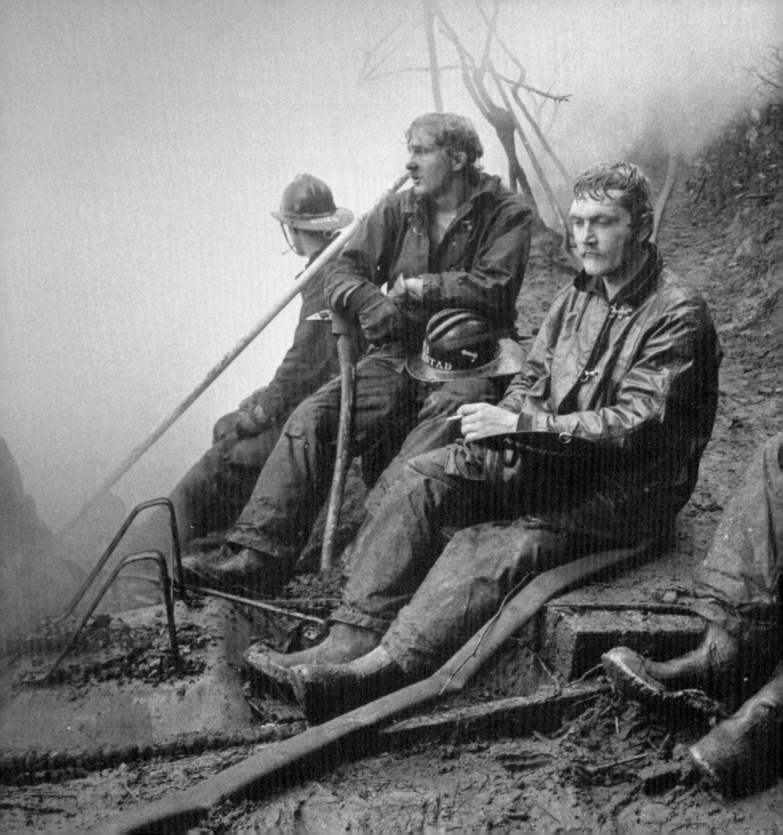

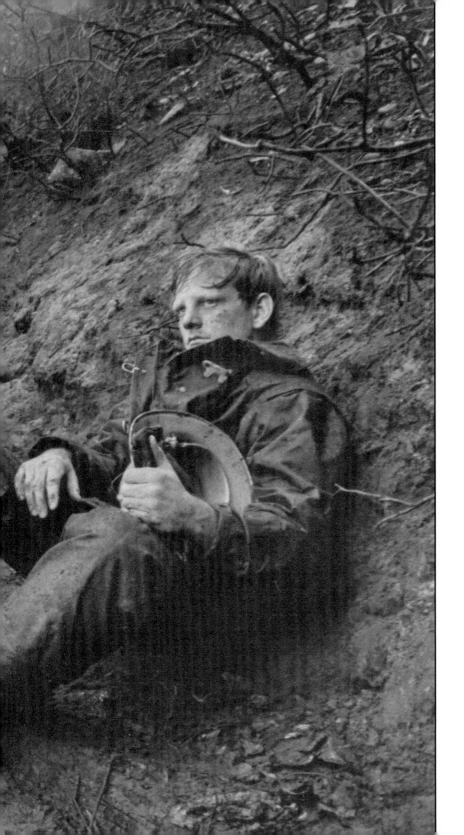

At age 28, while a photojournalist at *The Seattle Times* I was honored with The Pulitzer Prize. My timeless picture, "Lull in the Battle", immortalizes firemen resting after battling an intense house fire.

October 11, 1974

HOW YOU SEE

IS

WHO YOU ARE